NEW YORK
IN THE THIRTIES

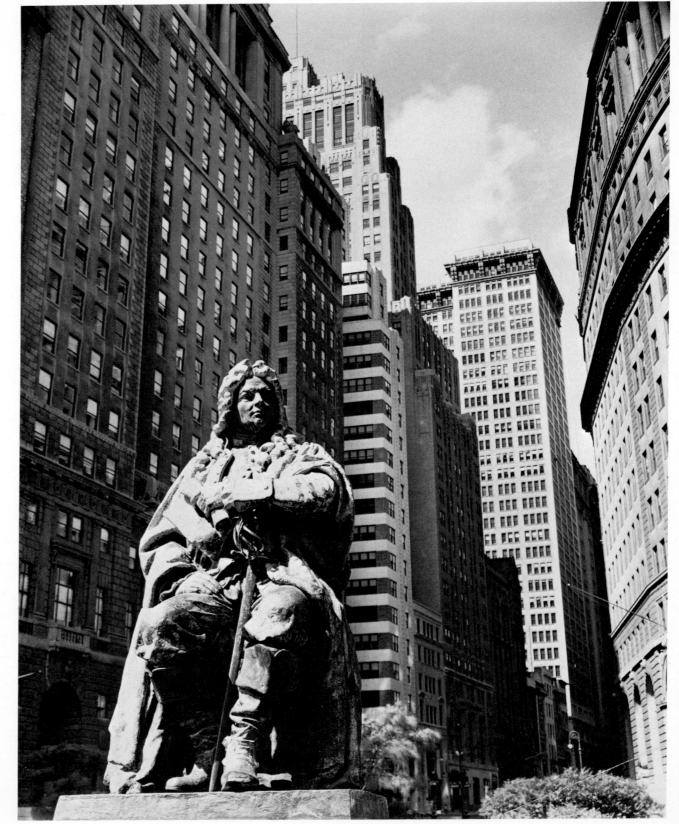

1. DE PEYSTER STATUE, Bowling Green, looking north to Broadway, Manhattan; July 23, 1936.* Erected: 1890. Sculptor: George Edwin Bissell (1839-1920).

❧ *Col. Abraham de Peyster (1658-1728) served as mayor, chief justice and president of the King's Council in Dutch colonial days. Two centuries passed, however, before he was immortalized in bronze. Today Bissell's statue stands in Bowling Green on the site where once stood a lead statue of George III, pulled down and melted for Revolutionary bullets.*

* The date on which the photograph was taken appears in the first part of each caption.

NEW YORK IN THE THIRTIES

[formerly titled: Changing New York]

AS PHOTOGRAPHED BY

Berenice Abbott

TEXT BY ELIZABETH McCAUSLAND

DOVER PUBLICATIONS, INC., NEW YORK

Published in Canada by General Publishing
Company, Ltd., 30 Lesmill Road, Don Mills, Toron-
to, Ontario.
Published in the United Kingdom by Constable
and Company, Ltd., 10 Orange Street, London
WC 2.

This Dover edition, first published in 1973, is an
unabridged republication of the work originally
published by E. P. Dutton & Company, Inc., New
York, in 1939, under the title *Changing New York*.
The original text is unaltered, except for the cor-
rection of typographical errors.
The publisher is grateful to The Museum of the
City of New York for making their original prints
of the photographs available for reproduction.

International Standard Book Number: 0-486-22967-X
Library of Congress Catalog Card Number: 73-77375

Manufactured in the United States of America
Dover Publications, Inc.
180 Varick Street
New York, N. Y. 10014

NEW YORK IN THE THIRTIES

Like many gifted American artists, Berenice Abbott was born in Ohio. After studying at the Ohio State University, she went abroad in 1921 for further experience in the field of art and in 1924 started working in the studio of Man Ray. She next turned to portrait photography. Joyce, Marie Laurencin, André Siegfried, Gide, Maurois and Cocteau are only a few of the great and near-great who sat for her camera eye, a vision described in a contemporary critique as "as uncompromising as Holbein's."

Early in the spring of 1929 she returned to the United States for a visit. While here she became so enthusiastic over what was going on about her that she determined that her work henceforward lay in America. After a brief trip to Paris to wind up her affairs she returned permanently to this country. Here the contrasts of a changed and changing city convinced her that a comprehensive portrait of New York was of more interest to her than portraits of people, and so emerged the idea of "Changing New York." With the aid of a small camera, the photographer now known as a "big camera" exponent began this record with tiny photographic notes. Very shortly she interested I. N. Phelps Stokes, Trustee of the New York Public Library, author of "Iconography of Manhattan Island" and member of the Municipal Fine Arts Commission, and Harding Scholle, director of the Museum of the City of New York, in her plan for a photographic documentation of New York City. Both of these connoisseurs are still vitally concerned with the undertaking and have aided it throughout.

The lack of private patronage for the arts and artists in general which was one of the chief factors contributing to the establishment of the Federal Art Project of the Works Progress Administration brought Berenice Abbott to us in 1935. Prior to that date a group of her photographs was shown at the opening of the Museum of the City of New York in 1932, and a comprehensive exhibition of this material in a one-man show was held in the same place two years later. Her second one-man exhibition in the Museum of the City of New York in October, 1937, under the auspices of the Federal Art Project, depicted "Changing New York" as a mature and vital record well under way. This will be deposited in its entirety in the Museum of the City of New York, the original sponsors of the venture, and portions of it have already found their way into such institutions as the Evander Childs High School, and the Central Commercial High School in New York City, the University of Minnesota, and the New York State Museum.

Only a small number of the hundreds of photographs produced are contained in this book, but enough appear to demonstrate the value of these data. The story told in dramatic contrast of old and new, of beauty and decay, is part of the function of this documentation. Scenes which were here two years ago and are gone today, and changes which are taking place are recorded in their relationship to the environment which remains. A truthful, sometimes humorous and often bitter commentary ensues.

Berenice Abbott does not wish to be called artistic. She

hates everything that is sentimental, tricky or devious. Her photographs are not dressed up with trailing clouds nor dramatized with superficial tricks or angle shots, soft lighting or oversimplification. This is "straight photography." Amid traffic, haste, vibration, crowds, confusion, she has set up her 8 x 10 camera, leveled it off with a tiny carpenter's spirit level, composed the image on the ground glass, focused it, calculated exposure, and taken the picture. But the layman must not think for an instant that these photographs were made by merely pressing a button. They are the work of a master artist who is a master craftsman as well.

The brief captions by Elizabeth McCausland accompanying the photographs in this book constitute only a small percentage of thousands of pages of factual material which document this photographic record. The untiring and enthusiastic work of the author is responsible for compiling this commentary. A staunch supporter of documentary photography, Elizabeth McCausland believes in the essential validity of Berenice Abbott's work.

However, the book was not created by these two people alone, but is the product of a cooperative effort. A group of technical and research workers, some over a long period of time and some for short term intensive work, have made contributions. Their names appear immediately following this foreword. Special credit, furthermore, must go to Lincoln Rothschild, head of the research division of the Index of American Design, for invaluable assistance in coordination of this research as well as for his general interest and aid.

Cooperative effort of this type is the keynote of the Federal Art Project. On a plan of group endeavor, the eighteen hundred workers who ply their crafts serve the people with murals for public buildings, teachers for underprivileged groups, visual campaigns against crime and disease, historic records of public achievements. Founded on a basis of the inherent right of the individual to work and of the preservation of skills, and under the inspiring guidance of the National Director, Holger Cahill, the Federal Art Project, the only public enterprise of its kind ever undertaken in this country and indeed unique in the world, takes its place, as does the documentation in this book, in the cultural history of this City and the United States.

AUDREY McMAHON

January, 1939

NEW YORK CITY FEDERAL ART PROJECT CONTRIBUTORS

Ralph Gutieri, *Supervisor, Photographic Division.*

Technical Workers: Frances Fein, Mabel Forster, Nels Nelson, Sam Shalet, Boris Stackliff, Mack Young.

Lincoln Rothschild, *Head of Research Division, Index of American Design.*

Research Workers: Louis Adorjan, Edith Brandinger, James Broughton, Emanuel Feller, Sidney Jacobs, Samuel Meidman, Roshelle Oksmann, Stavros Razotos, Sally Sands, Joseph Shore, Eleanor Somkin, Elsie Spier, Charles White, Scott Williamson.

LIST OF PLATES

NEW YORK
IN THE THIRTIES

The reader should keep in mind that the text accompanying Miss Abbott's photographs was prepared by Elizabeth McCausland for the original (1939) edition of this work. It has not been altered or abridged for the present edition.

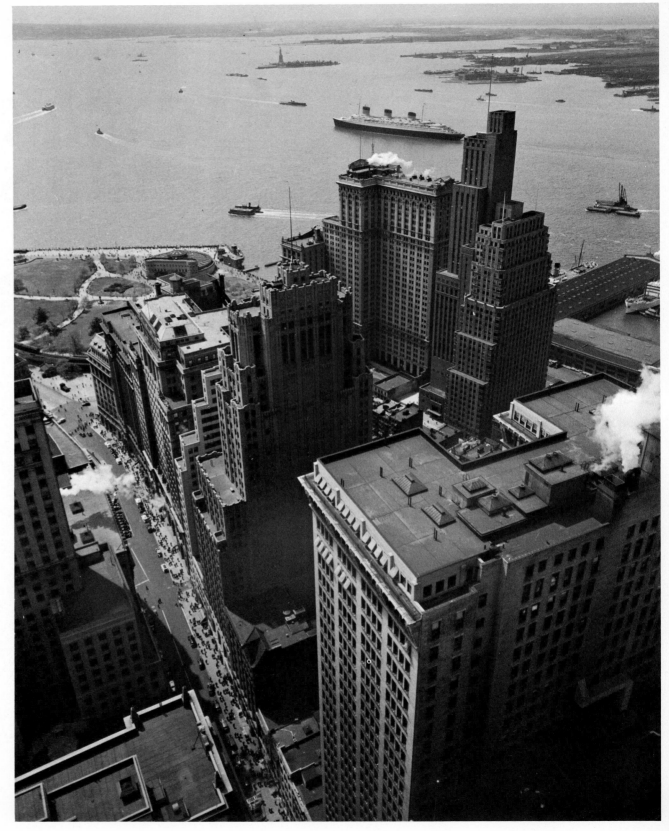

2. BROADWAY TO THE BATTERY, from roof of Irving Trust Co. Building, One Wall Street, Manhattan; May 4, 1938. Important skyscrapers to be seen are: lower right, Adams Building; just above it, Fred C. French Building; to the right, Whitehall Building and Downtown Athletic Club.

❧ *Looking down Broadway to the Battery from the roof of the Irving Trust Co. Building, the spectator observes familiar sights—Battery Park, the Aquarium, liners and tugs in New York harbor, and in the distance, the Statue of Liberty. Narrow Exchange Place is nestled into the lower left-hand corner.*

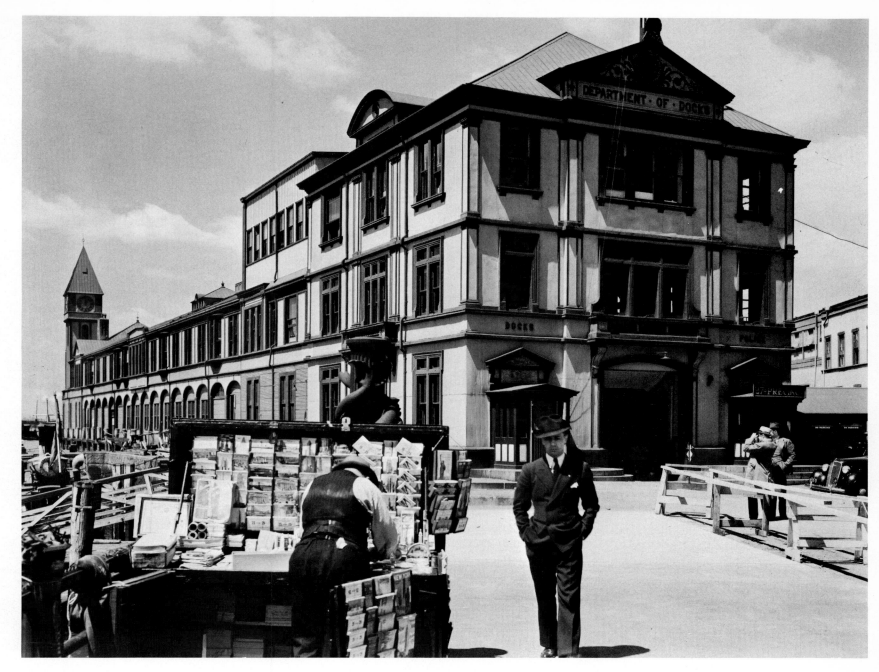

3. DEPARTMENT OF DOCKS AND POLICE STATION, Pier A, North River, Manhattan; May 5, 1936. Built in 1872 at cost of $185,000 from plans of an anonymous draughtsman of the department.

❧ *Gateway to the city, the Department of Docks Building at Pier A, North River, welcomes many distinguished visitors. Taken off incoming liners and whisked up the harbor in a marine police boat, these have ranged from Lindbergh to Queen Marie.*

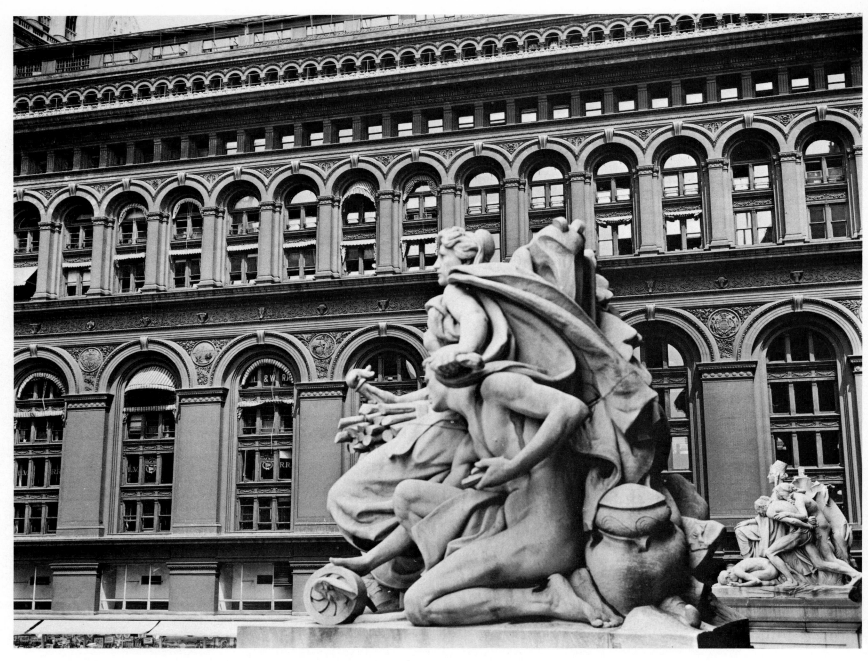

4. CUSTOM HOUSE STATUES AND NEW YORK PRODUCE EXCHANGE BUILDING, Bowling Green, Manhattan; July 23, 1936. Left, New York Produce Exchange Building, and right, U. S. Custom House. Built: 1884 and 1907. Architect: George B. Post; Cass Gilbert. Sculptor for Custom House statues: Daniel Chester French.

❧ *"A big, burly, solid structure, which no one can love very heartily, but which everyone must respect," wrote Russell Sturgis in 1898 of the New York Produce Exchange Building.*

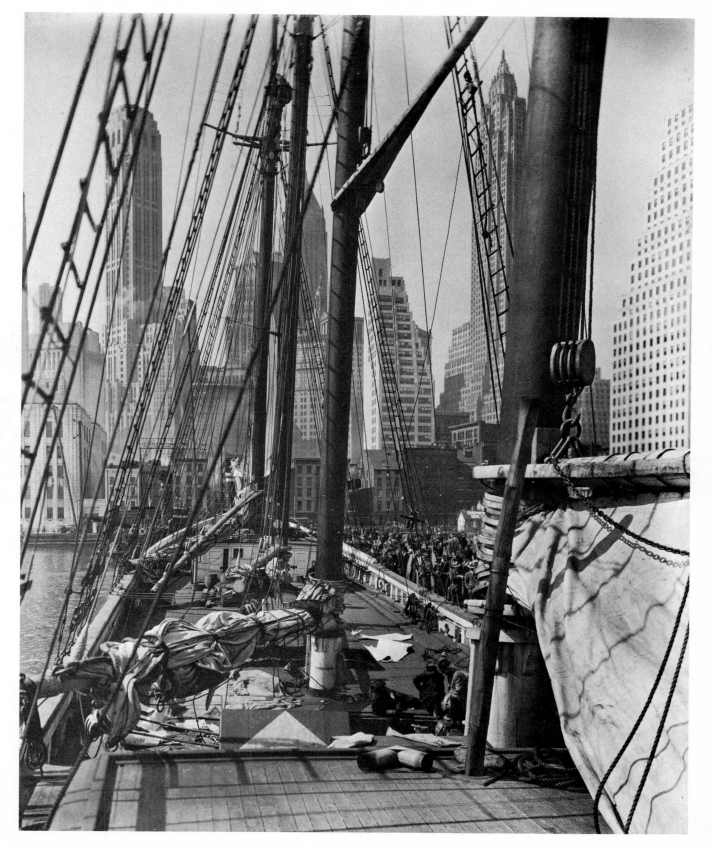

5. "THEOLINE," Pier 11, East River, Manhattan; April 9, 1936.

Fore, main, mizzen and spanker masts; flying, inner and under jib staysails and four lower and four topsails—the "Theoline" flaunts its rigging against the towers of lower Manhattan. Built at Rockland, Maine, in 1917, the schooner originally made Boston its home port, New York since 1937. It makes trips from New York every three or four months, carrying whatever cargo it can get.

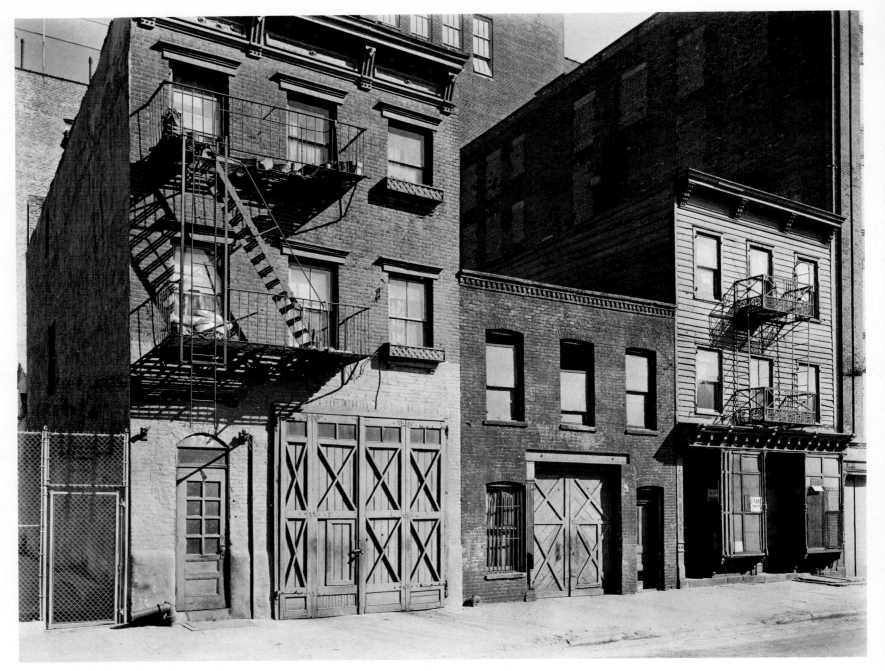

6. STANTON STREET, NOS. 328-332, Manhattan; March 4, 1937.

❧ No. 330 was built in 1884 as a workshop and one-family house; converted the next year into a stable. Today it shelters a small carbonated water concern. In addition to dwelling quarters, other buildings provide garage space and housing for a pickle factory, which also manufactures salad oil, olives, jellies, mustard, vinegar, relish, and horse-radish.

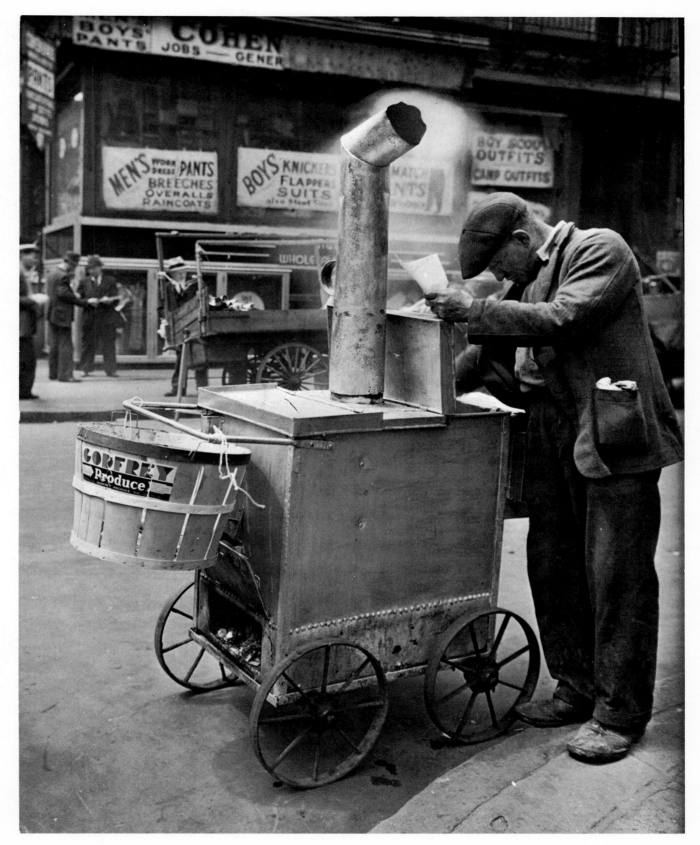

7. ROAST CORN MAN, Orchard and Hester Streets, Manhattan; May 3, 1938.

❧ *A "colored man" was seen selling "hot corn" one cold winter night in 1834 at Peck's Slip, according to Philip Hone's diary. Only lately have peddlers been the focus of a vigorous campaign to remove them from the streets and place them in city-controlled markets. A picturesque adjunct has been the pushcart "stable," in which the carts are bedded down at night and from which they are rented out by day, all for 25 cents.*

8. WALL STREET, SHOWING EAST RIVER, from roof of Irving Trust Co. Building, One Wall Street, Manhattan; May 4, 1938. From lower left-hand corner diagonally to upper right-hand corner, three outstanding buildings are: Bankers Trust Co. Building; Bank of Manhattan Building; 120 Wall Street. Located at: 16 Wall Street; 40 Wall Street; 120 Wall Street. Built: 1912; 1931; 1931. Architect: Trowbridge & Livingston; N. Craig Severance; Buchman & Kahn.

❧ *The pyramidal roof of the Bankers Trust Co. Building, derived from classical architecture, is echoed in the modern setback silhouette of 120 Wall Street. In the roof's-eye view of the financial district, serrated roof-lines create a pattern like that of the West's vast canyons, in which soil erosion has carved out abstract sculptures of earth and stone.*

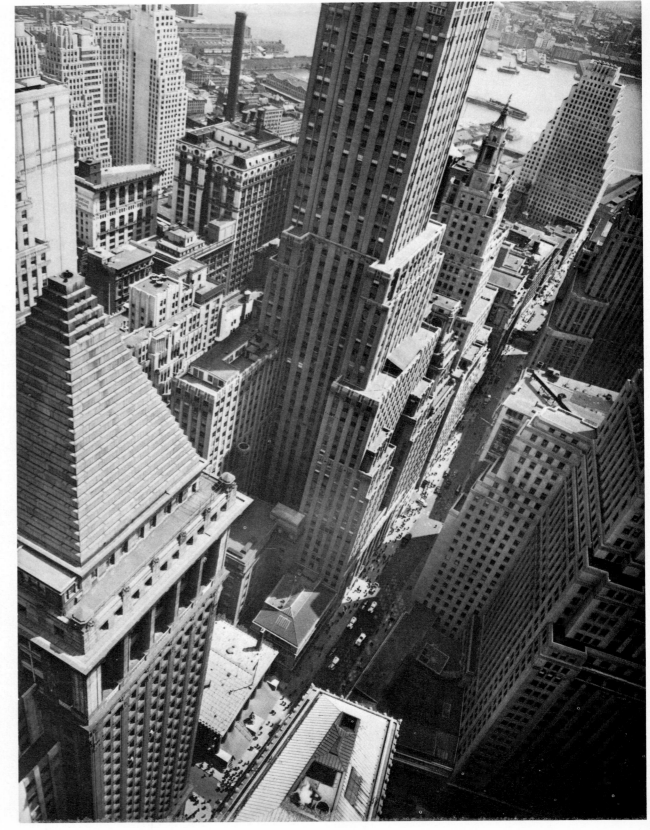

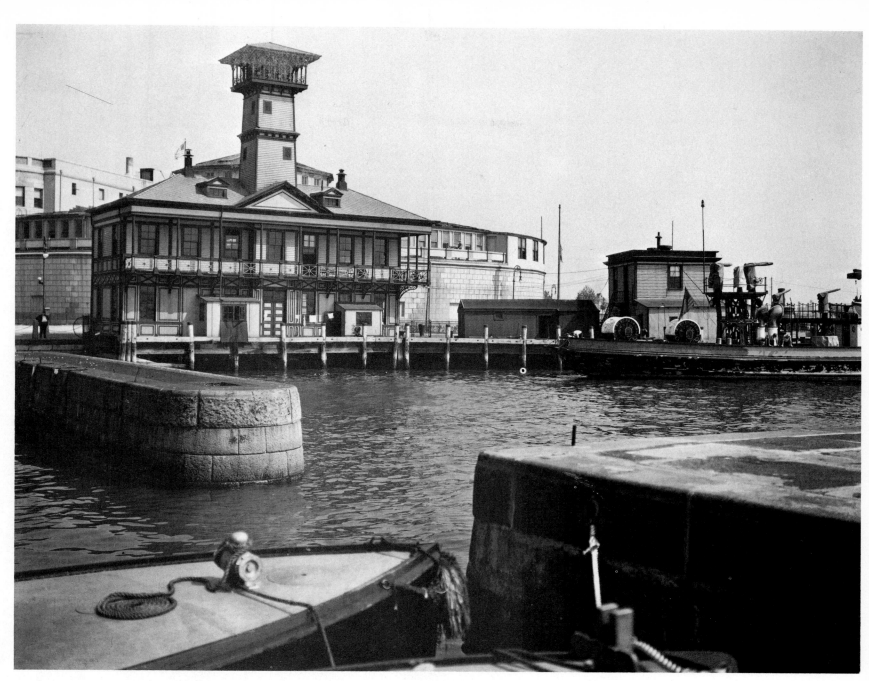

9. FIREHOUSE, BATTERY, Manhattan; May 12, 1936.

❧ *Now an architectural curiosity, the firehouse at the Battery has received such perfunctory consideration in the past that the records of its original construction cannot be found. Probably it was built at the same time as the Department of Docks across the park, namely, 1886. The fireboat assigned to the station, the "John J. Harvey," which was built in 1931 and has been in service ever since, is used for fighting fires in buildings on the water front and on boats at docks and in the harbor.*

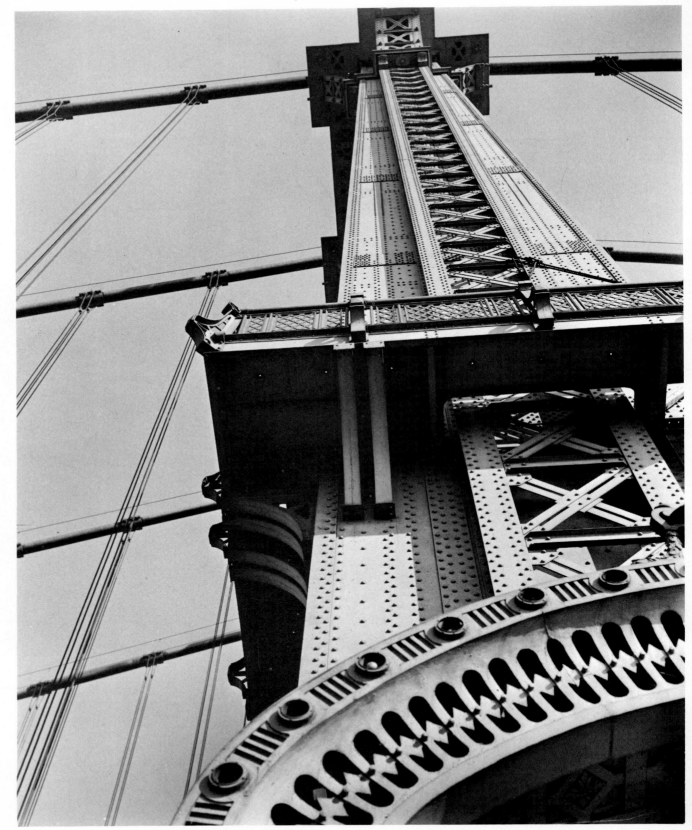

10. MANHATTAN BRIDGE: LOOKING UP; November 11, 1936. Built: 1909. Chief engineer: C. M. Ingersoll.

Fourth to span the East River, the Manhattan Bridge extends from the Bowery and Canal Street, Manhattan, to Nassau and Bridge Streets, Brooklyn. Although not so superb an engineering achievement as Brooklyn Bridge, Manhattan Bridge performs very useful transit functions, with eight railroad lines on different levels.

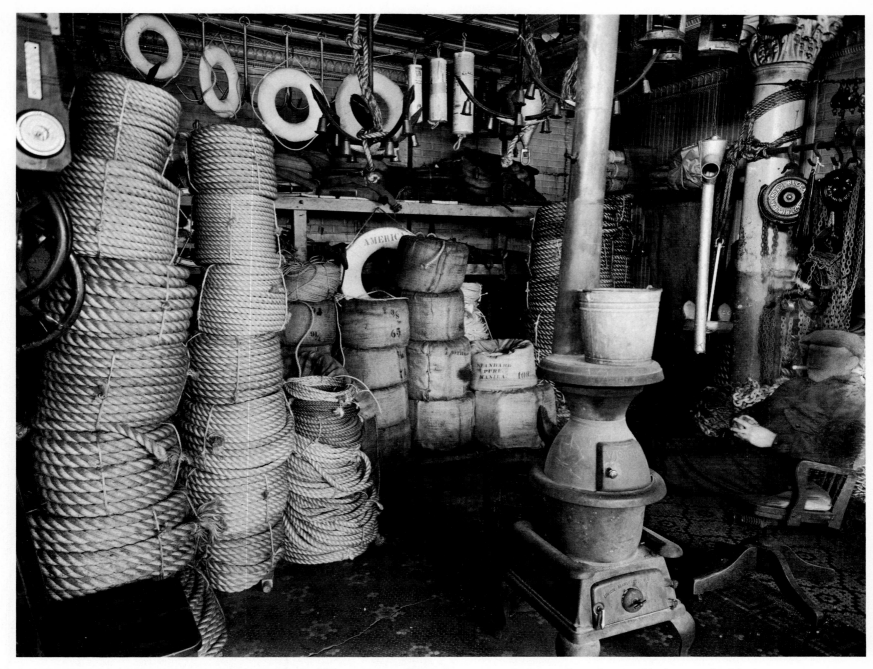

11. ROPE STORE: PEERLESS EQUIPMENT CO., 189 South Street, Manhattan; February 5, 1936.

❧ *Manila rope, wire rope, chain hoists, blocks, turnbuckles, clips, hooks, chains, anchors and shackles, boat covers—the rope store displays its wares in full view.*

12. CANYON: BROADWAY AND EX-
CHANGE PLACE, Manhattan; July 16,
1936. Left to right, Exchange Court Build-
ing, Adams Building, North American
Building; located at 52, 61 and 60 Broad-
way. Architect: Clinton & Russell;
Francis H. Kimball; McKim, Mead &
White. Built: 1898; 1914; 1907.

❦ *Barely 25 feet wide, Exchange Place
is overhung by the skyscrapers, 300 and
400 feet high, on either side. Originally
a path leading to the city fortifications, in
British colonial times it was called Oyster
Pasty Alley.*

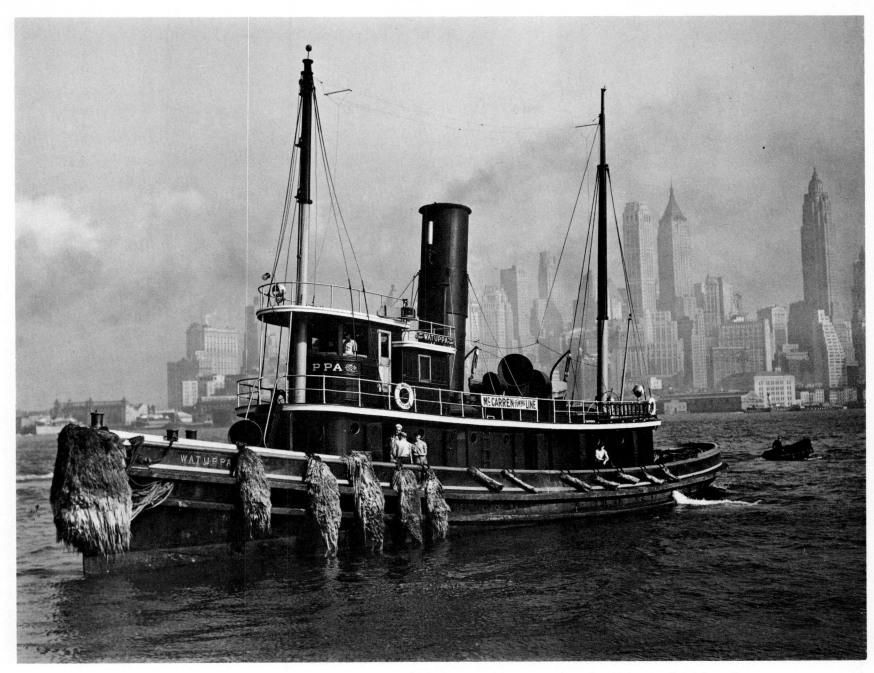

13. "WATUPPA," from water front, Brooklyn; August 10, 1936.
Built: 1906, at Burleigh Shipyard, Staten Island.

❧ *Water-front history credits the "Watuppa" with gallant deeds. In the bad winter of 1934-5, it helped keep the ice-bound Hackensack River open and made a spectacular trip to the rescue of a 15,000-barrel oil barge at Poughkeepsie. Tugs are in actuality the unsung heroes of American waterways, the inland water-route trade of the United States being 20 times greater than its ocean commerce. In New York State alone tugs annually tow 18,500,000 tons of freight, including wheat, coal, iron, lumber, through rivers and waterways such as the Erie Canal and the Hudson and East Rivers.*

14. WATER FRONT: FROM PIER 19, EAST RIVER, Manhattan; August 12, 1936.

❧ To city-owned Piers 19 and 20 come the 15 vessels of Standard Fruit & Steamship Co., carrying bananas—and a few passengers—to New York and Philadelphia from Mexico, Central America, Honduras, San Salvador, the West Indies, Cuba, Jamaica and Puerto Rico. The green fruit must be kept at a constant temperature of 56° F., to ripen en route.

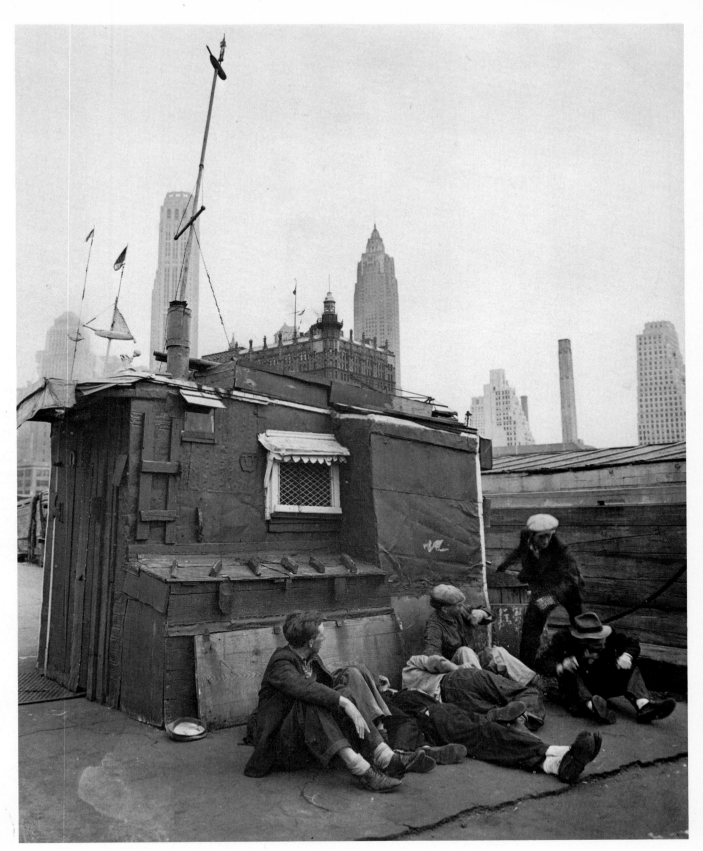

15. SHELTER ON THE WATER FRONT,
Coenties Slip, Pier 5, East River, Manhattan; May 3, 1938.

❧ *Not a Hooverville shanty, but a watchman's home is this shelter on the water front at Coenties Slip. Thirty years old, the shelter has seen death eddy around the pier, for the watchman now in charge is reputed to have rescued no less than 200 people from drowning.*

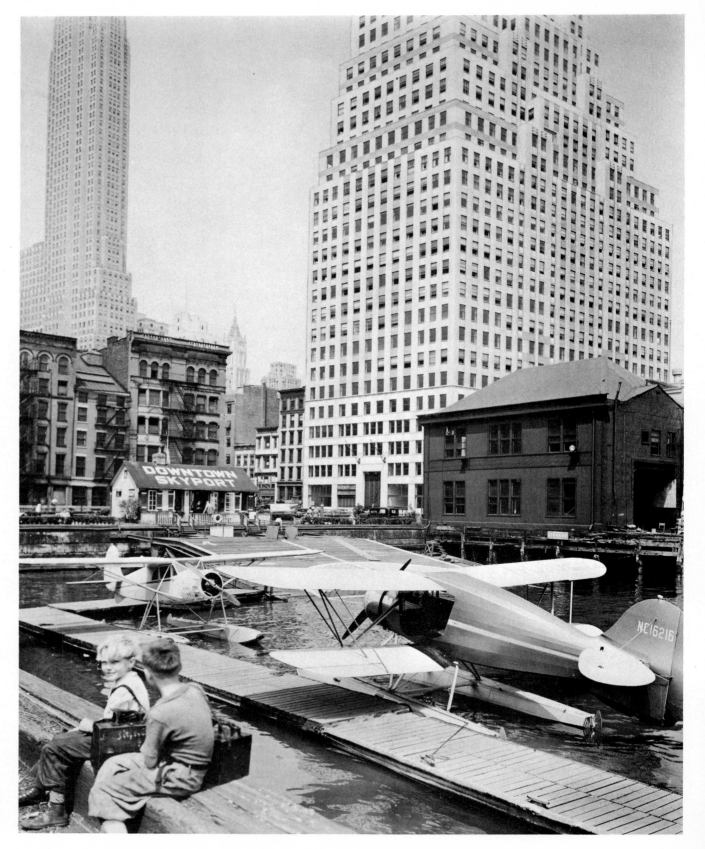

16. DOWNTOWN SKYPORT, foot of Wall Street, East River, Manhattan; August 12, 1936. Designed by United Dry Docks, Inc. Owned by New York City and operated by Department of Docks.

❧ *Built by WPA labor on a site whose rental value is estimated at $200,000, the Downtown Skyport brings Wall Street close to air commuters from Oyster Bay, Boston and Philadelphia.*

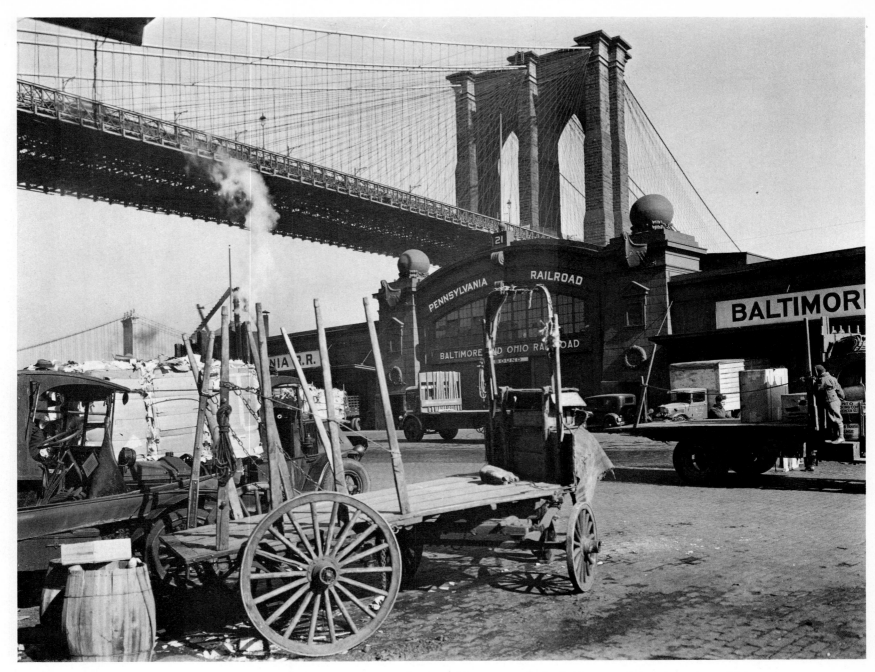

17. BROOKLYN BRIDGE, WITH PIER 21, PENNSYLVANIA R. R.,
Manhattan; March 30, 1937. Designed and built by engineers
John A. Roebling and Col. Washington A. Roebling; opened to
public May 24, 1883. Owned by New York City, under the
supervision of the Public Works Department.

☙ *The cable towers of the bridge stand 272 feet above high
water, to support the main span of 1600 feet. Sunk deep in the
East River by virtue of the Roeblings' heroic struggles with
caissons and caisson disease (the "bends"), the towers withstand
the stress of approaches reaching to City Hall Park, Manhattan,
and to Sands and Washington Streets, Brooklyn, a total distance
of a mile and a sixth.*

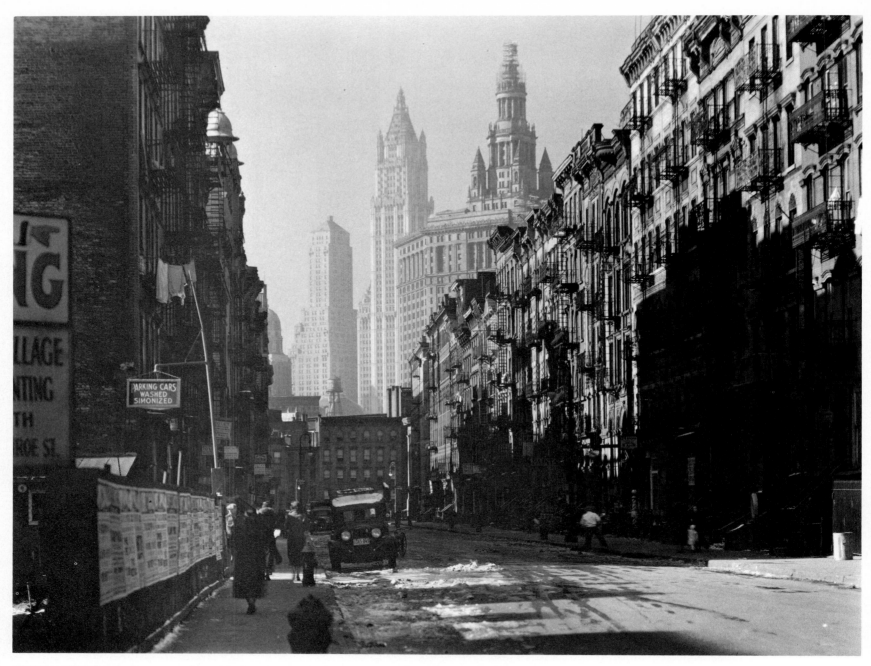

18. HENRY STREET, looking west from Market Street, Manhattan;
November 29, 1935.

The old Post Office and the Transportation, Woolworth and Municipal Buildings look down on Henry Street, where half a century ago some of America's oldest settlement houses were founded. Just around the corner on Oliver Street "Al" Smith was born.

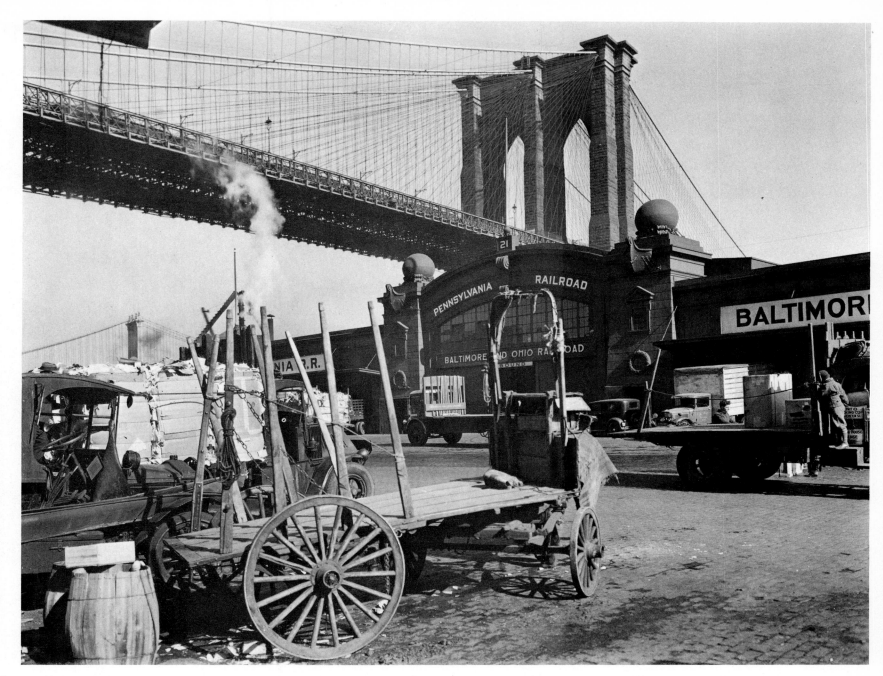

17. BROOKLYN BRIDGE, WITH PIER 21, PENNSYLVANIA R. R., Manhattan; March 30, 1937. Designed and built by engineers John A. Roebling and Col. Washington A. Roebling; opened to public May 24, 1883. Owned by New York City, under the supervision of the Public Works Department.

❧ *The cable towers of the bridge stand 272 feet above high water, to support the main span of 1600 feet. Sunk deep in the East River by virtue of the Roeblings' heroic struggles with caissons and caisson disease (the "bends"), the towers withstand the stress of approaches reaching to City Hall Park, Manhattan, and to Sands and Washington Streets, Brooklyn, a total distance of a mile and a sixth.*

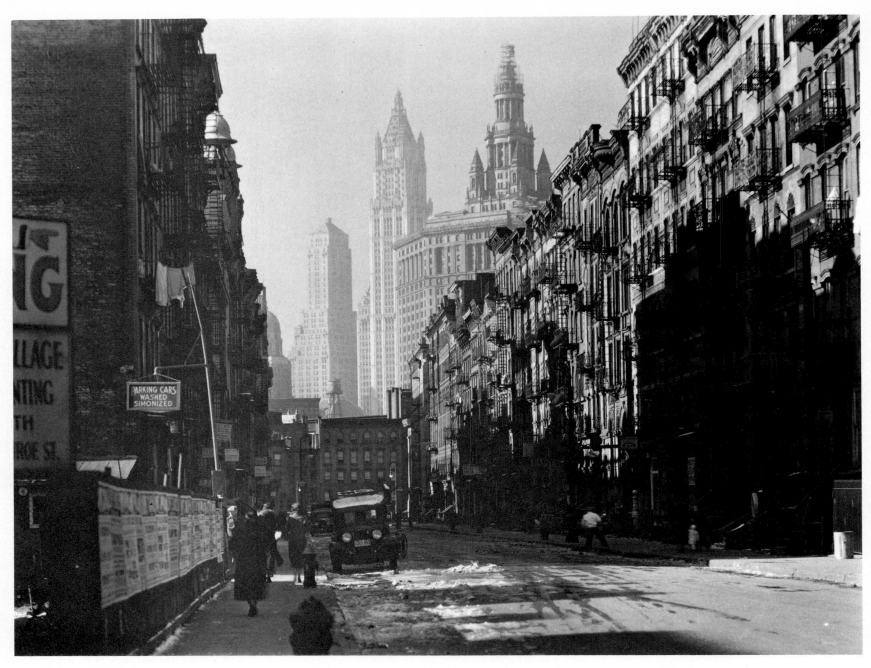

18. HENRY STREET, looking west from Market Street, Manhattan;
November 29, 1935.

❧ *The old Post Office and the Transportation, Woolworth and Municipal Buildings look down on Henry Street, where half a century ago some of America's oldest settlement houses were founded. Just around the corner on Oliver Street "Al" Smith was born.*

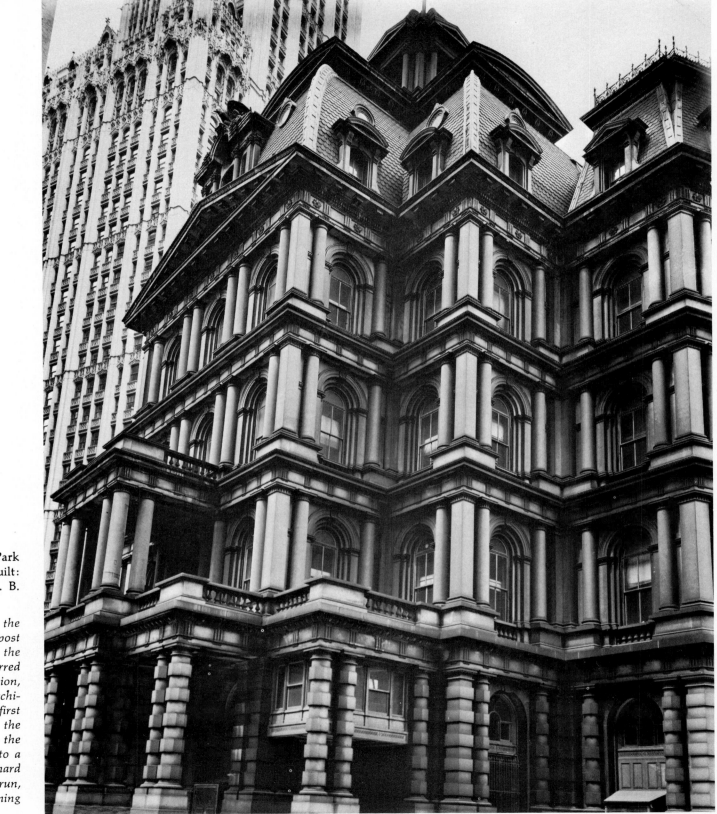

19. OLD POST OFFICE, Broadway and Park Row, Manhattan; May 25, 1938. Built: 1869-1878. Supervising architect: A. B. Mullett.

❧ *Twenty-two years elapsed between the act of Congress authorizing a new post office and the actual occupation of the edifice. Between 1856 and 1878 occurred the American Civil War, Reconstruction, and one of the most extraordinary architectural competitions of history. No first or second prize was granted. Instead the government took the best points of the top 15 plans and scrambled them into a monument of eclecticism, with Richard M. Hunt, Renwick & Sands, N. Le Brun, J. Correja and Schulze & Schoen forming the supervisory committee.*

20. LEBANON RESTAURANT, 88 Washington Street, Manhattan; August 12, 1936.

☙ *Here in the heart of the Syrian district are dispensed shish kebab, stuffed grape and cabbage leaves, baklava and halva, with demitasses of thick black syrupy "Turkish" coffee. Not only the signs in Arabic letters reveal the ancient culture of the Near East which the Syrians have brought to America with them, but the very traditions of cooking carry on old habits.*

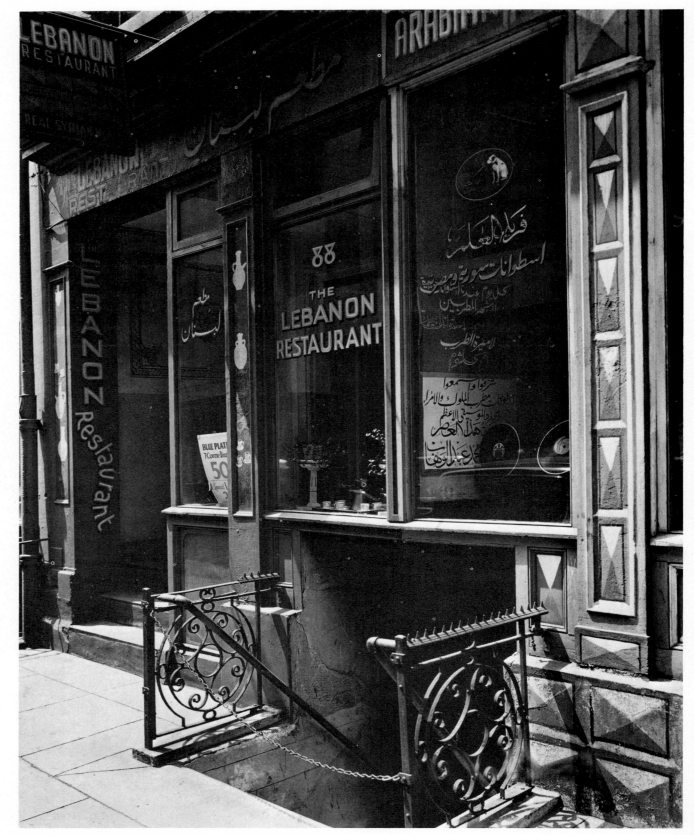

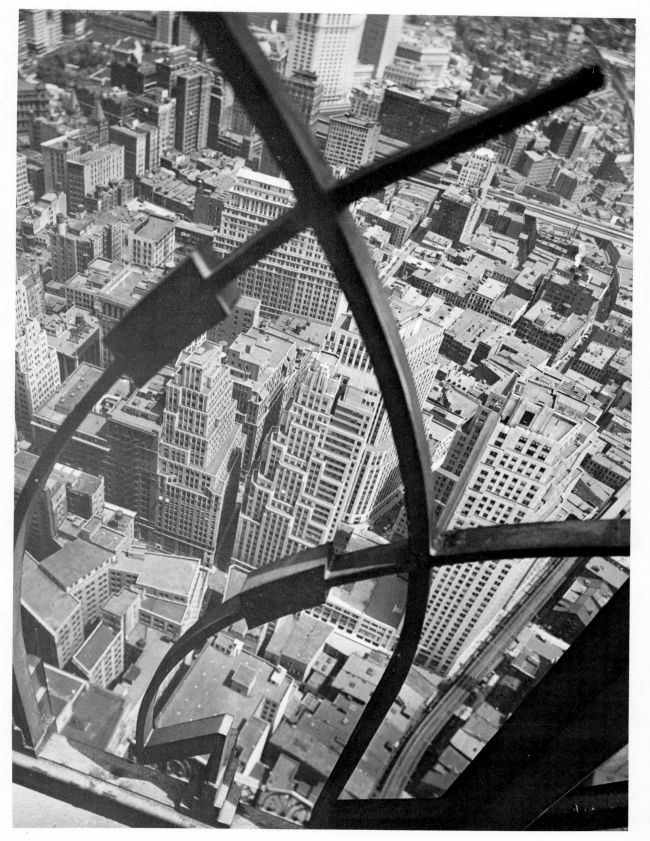

21. CITY ARABESQUE, from the roof of 60 Wall Tower, 70 Pine Street, Manhattan; June 9, 1938. Built: 1932. Architect: Clinton & Russell.

❧ *Northeast from the roof of Sixty Wall Tower the financial district spreads out in an arabesque. In the extreme upper left corner is to be seen City Hall Park, while the "El" winds in and out of view along the right-hand edge. The 1562.5-foot Manhattan approach of Brooklyn Bridge may also be seen cutting sharply across the upper right-hand corner, and the beginnings of the Lower East Side appear beyond the bridge.*

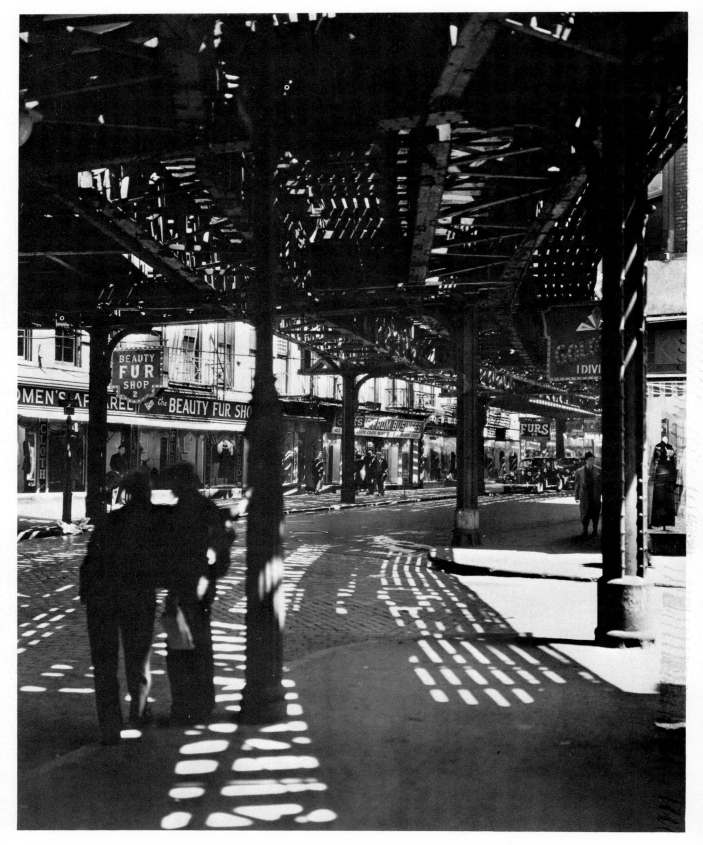

22. "EL," SECOND AND THIRD AVENUE
LINES, Bowery and Division Street, Man-
hattan; April 24, 1936. Built: 1878, by
Metropolitan Elevated Railway Co. Orig-
inal owner: New York Elevated Railroad
Co., the Third Avenue line and Gilbert
Elevated Company, the Second Avenue
line. Present owner: Interborough Rapid
Transit Company.

❧ *The 999-year lease of the Metropolitan
Elevated Railway Company's lines to the
Manhattan Railroad Company will not
expire till 2878; and no doubt by then all
the "Els" will be torn down. First drawn
by cables, then by "dummy" steam en-
gines, the lines were electrified in 1902.*

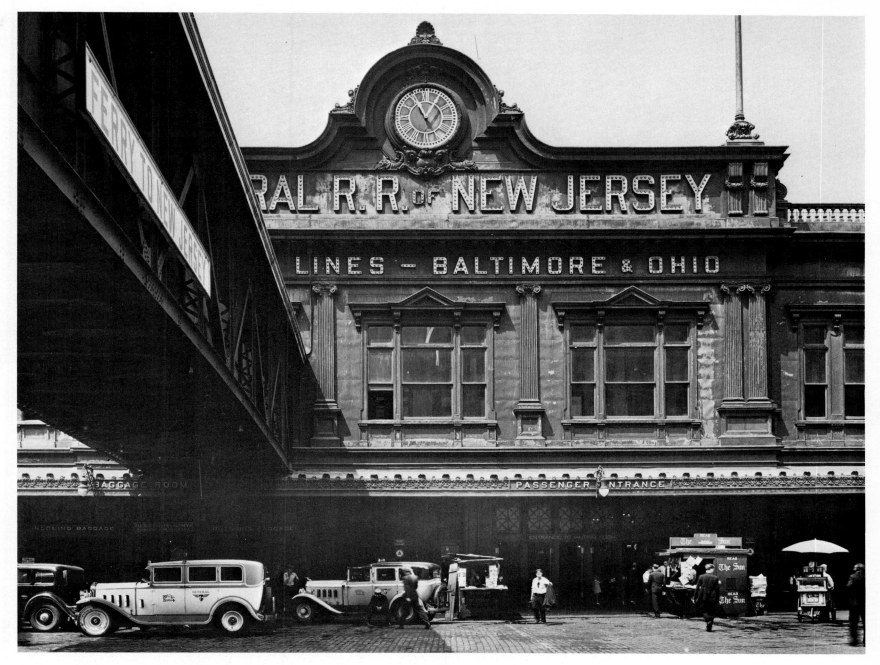

23. FERRY, CENTRAL RAILROAD OF N.J., West Street, foot of Liberty Street, Manhattan; August 12, 1936. Built: 1905-1909. Designed and erected under supervision of Joseph O. Osgood, chief engineer, C.R.R.N.J.

❧ *Manhattan is an island, which created a traffic problem when the frontier moved west of the Hudson. Especially complicated is the railroad situation, at least six lines having their terminals in Jersey—the Central Railroad of New Jersey, the Erie, Lackawanna, West Shore, Reading and the Baltimore & Ohio. The first four maintain their own ferry services.*

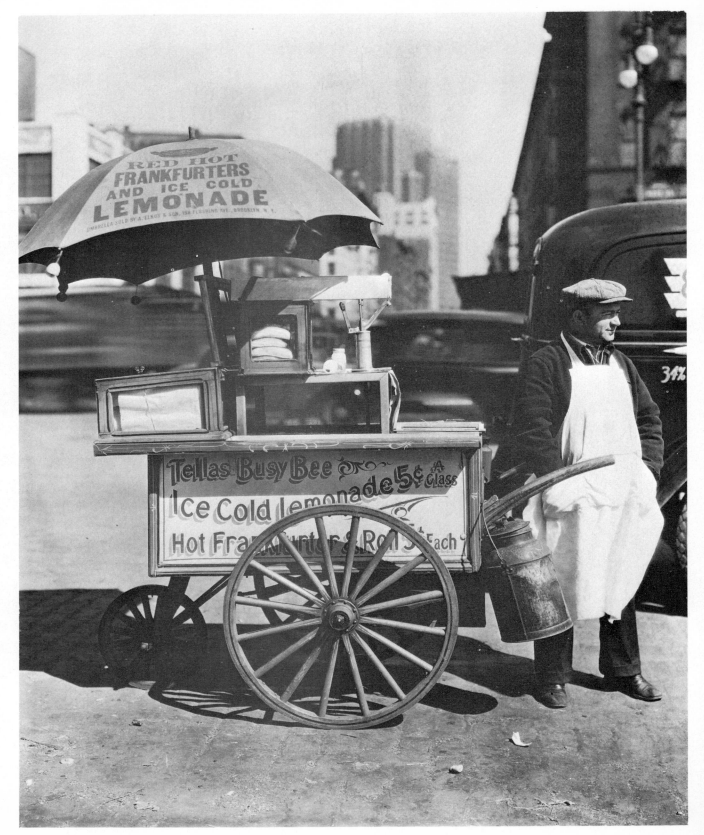

24. HOT DOG STAND, West Street and North Moore Street, Manhattan; April 8, 1936.

❧ *Fourteen thousand pushcart peddlers, selling candy, roast corn, baked sweet potatoes, roasted chestnuts, hot dogs, soft drinks, vegetables and fruits, were banished from the streets of New York in 1938 by order of the Commissioner of Markets. They are being corralled into modern enclosed markets, municipally operated.*

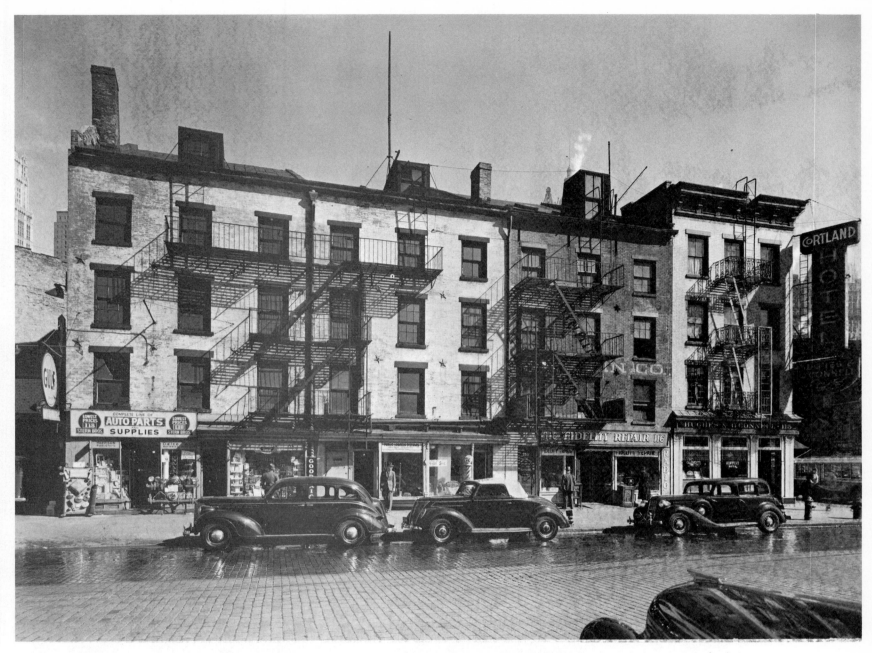

25. WEST STREET ROW, 115-118 West Street, Manhattan; March 23, 1938.

❧ *The two white houses at the left, 117 and 118, were built in 1840. As a portion of the Frank A. Munsey estate they have become part of the endowment of the Metropolitan Museum of Art.*

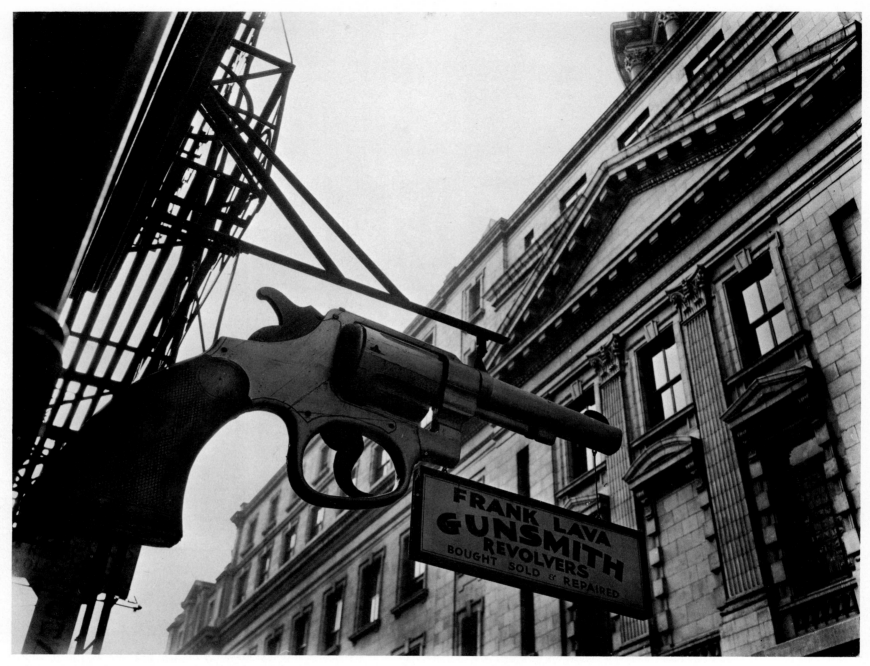

26. GUNSMITH AND POLICE DEPARTMENT, 6 Centre Market Place and 240 Centre Street, Manhattan; February 4, 1937. Built in 1850 and 1906. Architect for Police Headquarters: Hoppin & Koehn.

❧ *Frank Lava's gun shop was founded in 1850 by Eli Parker. It closed up during the Civil War, but was re-opened in 1870 by ancestors of the present owner. The Lava shop used to do repair work for the police, until the department retained its own armorers. It still does work, however, for the sheriff's staff.*

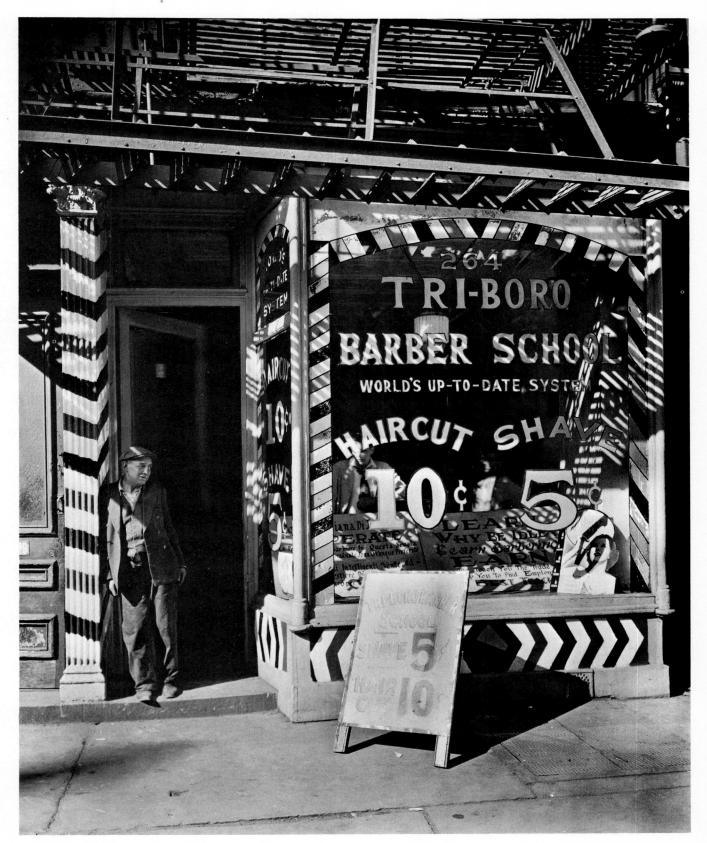

27. TRI-BORO BARBER SCHOOL, 264
Bowery, Manhattan; October 24, 1935.

❧ *The Bowery is the center of barber
schools, two or more of which may be
seen in every block. The Tri-Boro went
out of business soon after it was photo-
graphed because new health regulations
cost too much for an already waning
concern.*

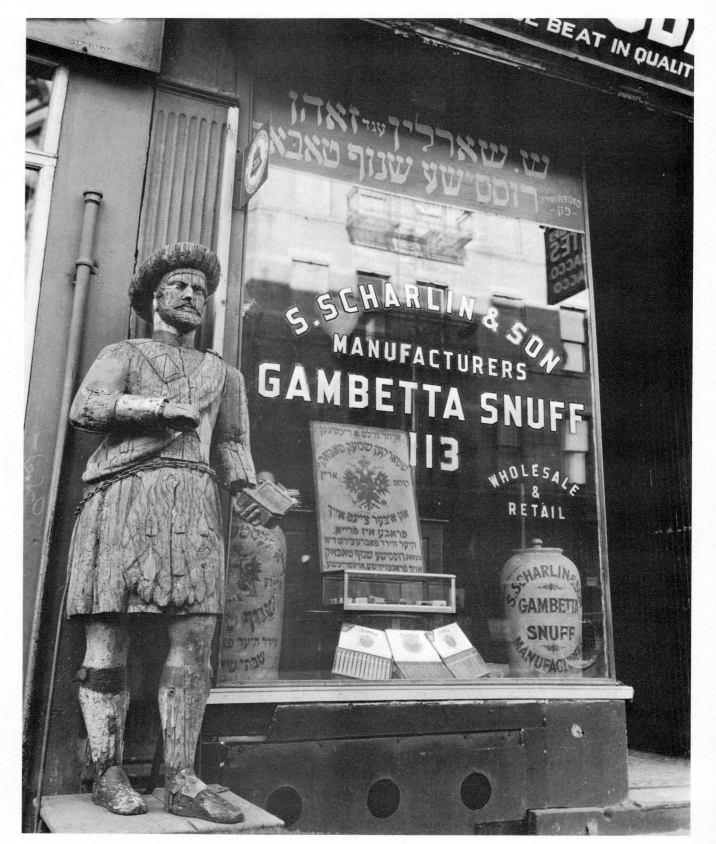

28. SNUFF SHOP, 113 Division Street, Manhattan; January 26, 1938.

☙ *Sandy, the "Scotch Indian," has had a series of adventures since his picture was taken in January, 1938. Confiscated by the Manhattan Department of Borough Works for obstructing the sidewalk, he was hauled off to the city dump in April, heartless officials paying no heed to his antiquity or authentic folk-art beauty. Rescued when his owner paid a $1 fine, the snuff-shop figure recently was sold to a collector.*

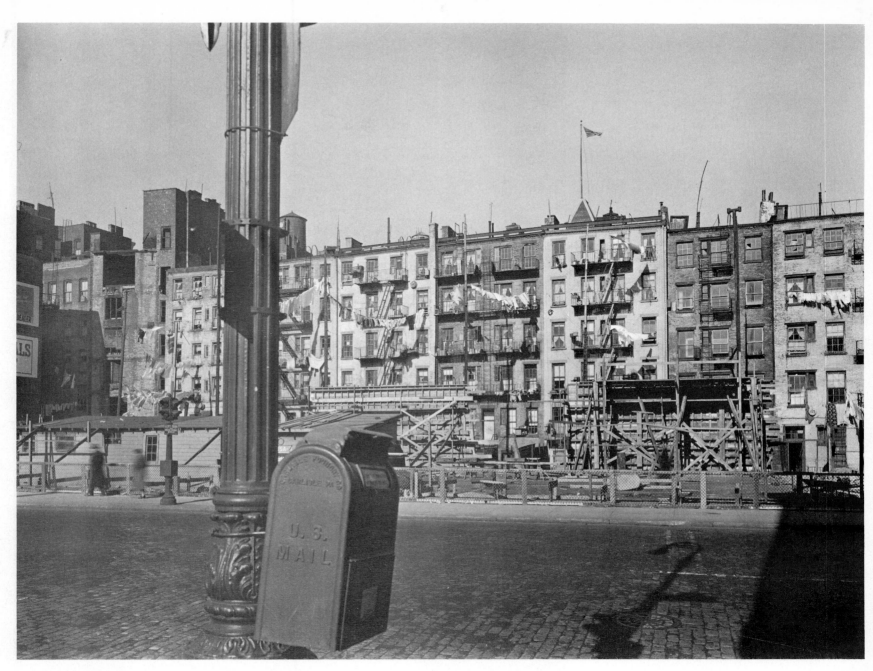

29. OLD-LAW TENEMENTS: FROM FORSYTH AND EAST HOUSTON STREETS, 35-47½ East First Street, Manhattan; February 11, 1937. Tenements date from 1867 to 1906.

❧ Old-law tenements to the number of 66,000 house 2,000,000 New Yorkers. The row shown here was revealed when the houses fronting East Houston Street were torn down some years ago to permit of constructing the Eighth Avenue line of the municipally owned Independent Subway.

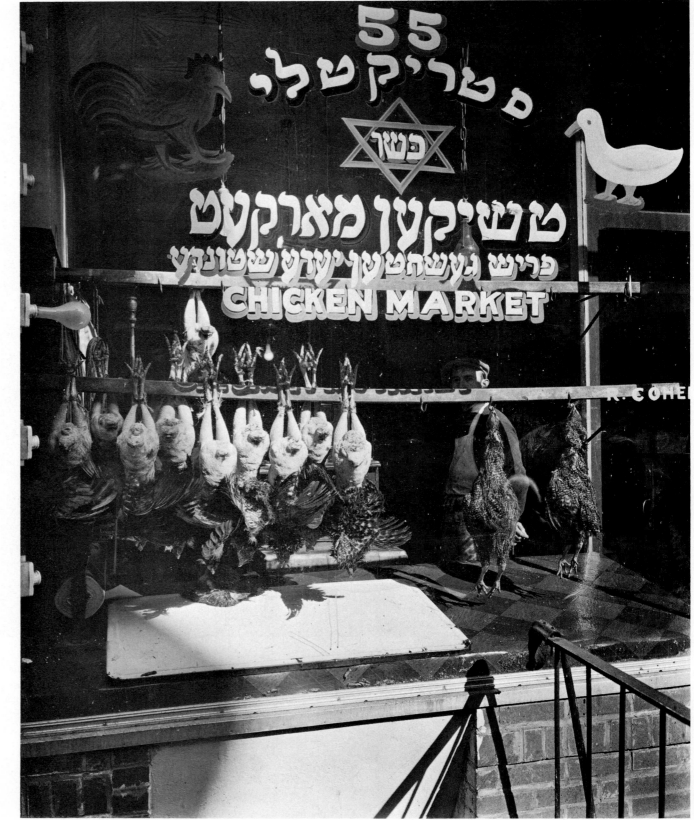

30. CHICKEN MARKET, 55 Hester Street, Manhattan; February 11, 1937.

❧ *"Strictly Kosher Chicken Market—Fresh Killed Hourly," reads the Yiddish sign of the East Side store. A complex dietary logic underlies the Jewish insistence that chickens must be newly killed before they are eaten and that before being cooked they must be soaked in water for half on hour and drained and salted for an hour.*

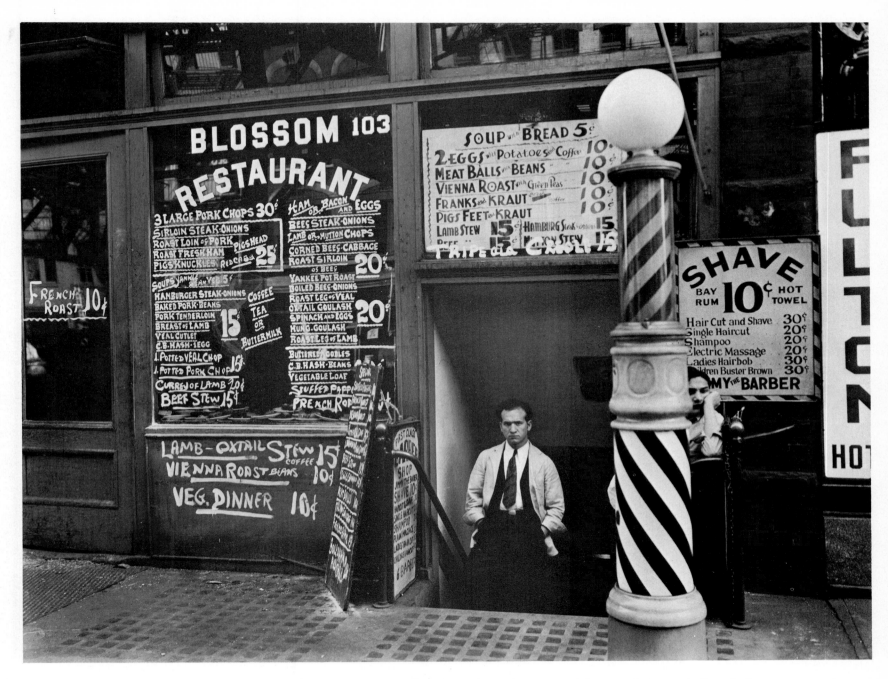

31. BLOSSOM RESTAURANT, 103 Bowery, Manhattan; October 24, 1935. Built prior to 1904.

❧ *Many of the city's transient labor population as well as single men on relief frequent the Bowery. The prices clearly displayed by the restaurant and barber shop are in keeping with the cost of 30 cents for a night's lodging in the "hotel" above them.*

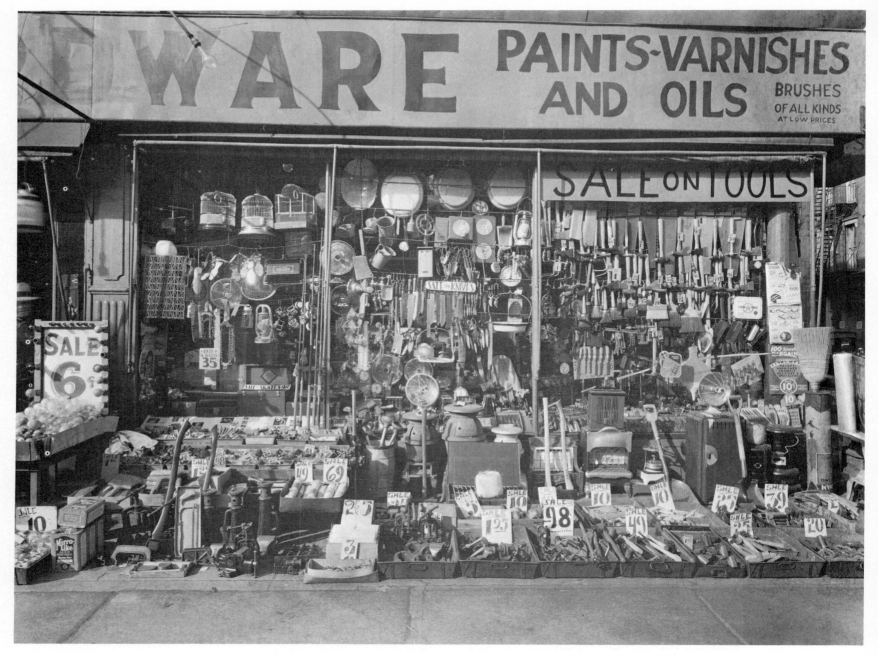

32. HARDWARE STORE, 316-318 Bowery, Manhattan; January 26, 1938. Premises built: 1868. Business established: 1907.

❧ *Functional, to say the least, is this fascinating congeries of "things." Many customers are "afraid" to come in and ask for an item unless they first see it in the window or in the sidewalk trays. Others, with a language barrier, simply point. Wheeled trucks are used to move the trays each night and morning. Canvas covers must be used in sudden rains, for it takes an hour to haul them in.*

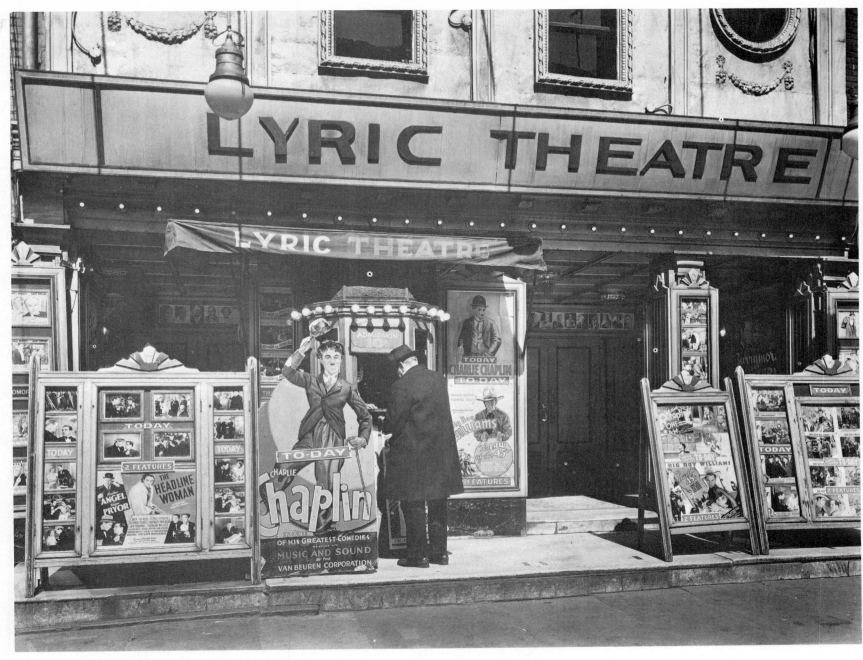

33. LYRIC THEATRE, 100 Third Avenue, Manhattan; April 24, 1936. Built about 1880. Present facade designed by George Mc-Cabe, architect, in 1910.

❧ *Fifty years ago this was the Sans Souci Concert Hall where Richard Croker had a private box. Today the Lyric Theatre offers transients, seafaring men, sightseers, slummers, visual fare of two features, newsreel and a "short"—all for ten cents. The doors open as early as 7 a.m., though the show does not start till eight; and patrons who did not have thirty cents for a night's lodging in a Bowery "hotel" can make up their sleep.*

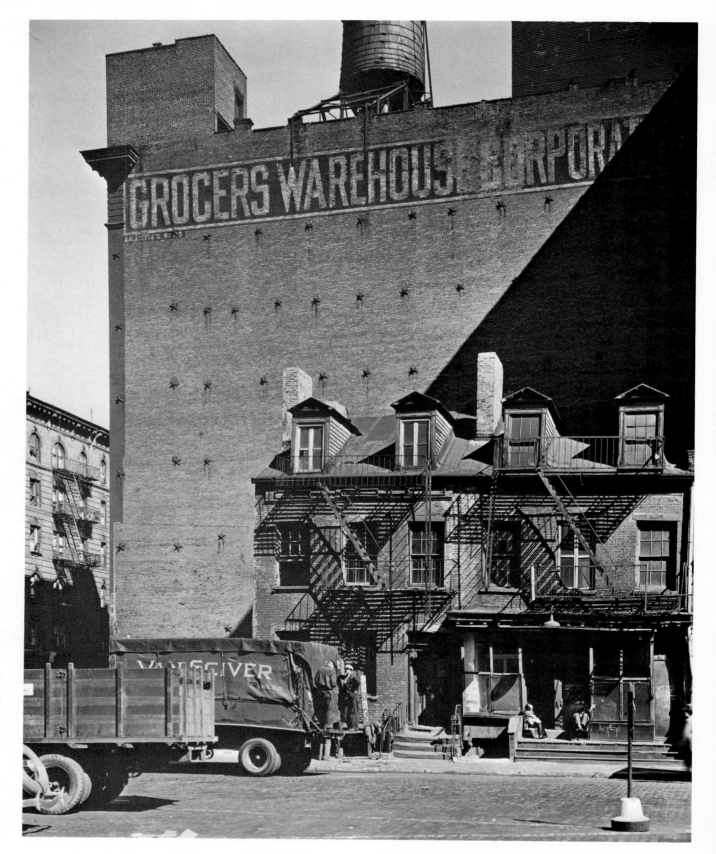

34. BROOME STREET, NOS. 512-514, Manhattan; October 7, 1935.

❧ *Built before the Civil War, altered in 1871 and again in 1921, these two old houses on Broome Street are obviously of an earlier day than the warehouse that overshadows them. Yet the anchor plates of the later building also indicate a structural technic antedating the modern steel frame. The size of their building lots, 20 x 50, in contrast with the standard 25 x 100 of the brownstone front era, suggests the smallness of colonial times.*

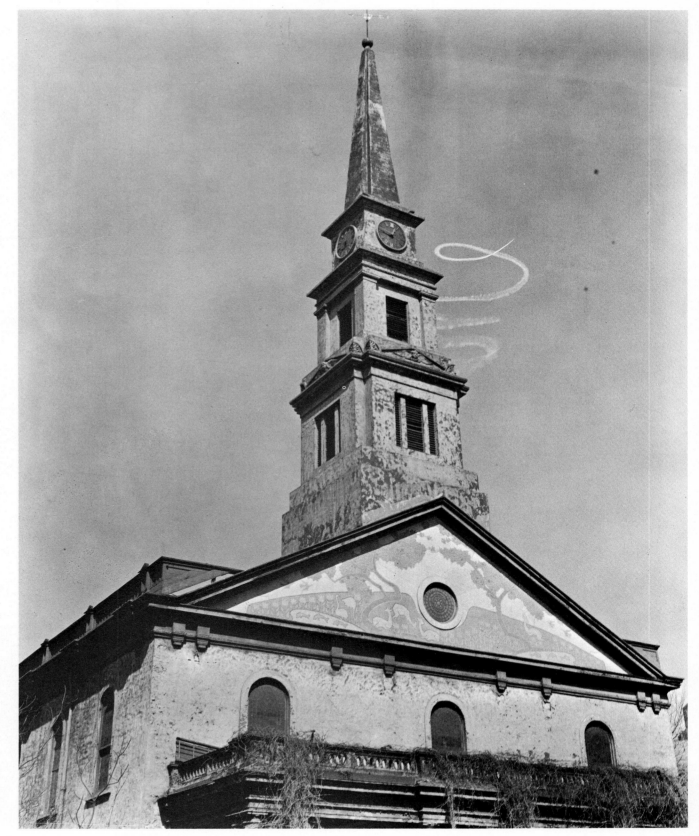

35. ST. MARK'S CHURCH WITH SKY-WRITING, East 10th Street and Second Avenue, Manhattan; March 23, 1937. Cornerstone laid April 25, 1795; consecrated, May 9, 1799.

☙ *St. Marks-in-the-Bouwerie, second oldest church building standing in New York City, occupies the oldest site of continuous religious worship in Manhattan. Here once stood the chapel built by Petrus Stuyvesant, last of the Dutch governors. Behind its steeple a skywriter pumps 250,000 cubic feet of smoke a second into advertising slogans.*

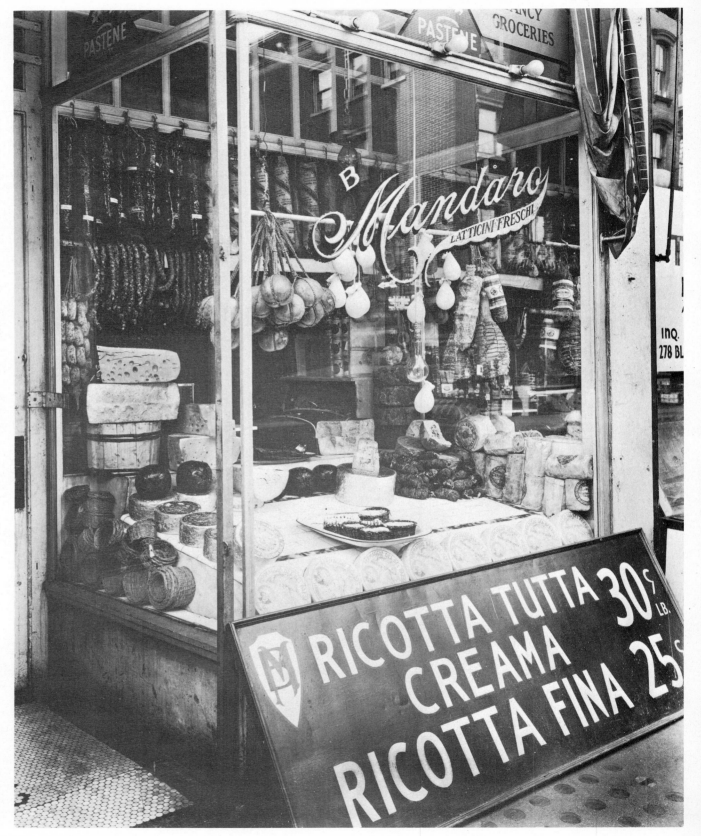

36. CHEESE STORE, 276 Bleecker Street, Manhattan; February 2, 1937. Built in 1904.

A thriving cheese business in an old-law tenement in Little Italy sells from 27,000 to 30,000 pounds a year. On land owned by Aaron Burr in 1804, B. Mandaro perpetuates the romance of caciocavallo, scamorza, mozzarella, ricotta, provola affumicata and so on through the 400 names of the world's cheeses.

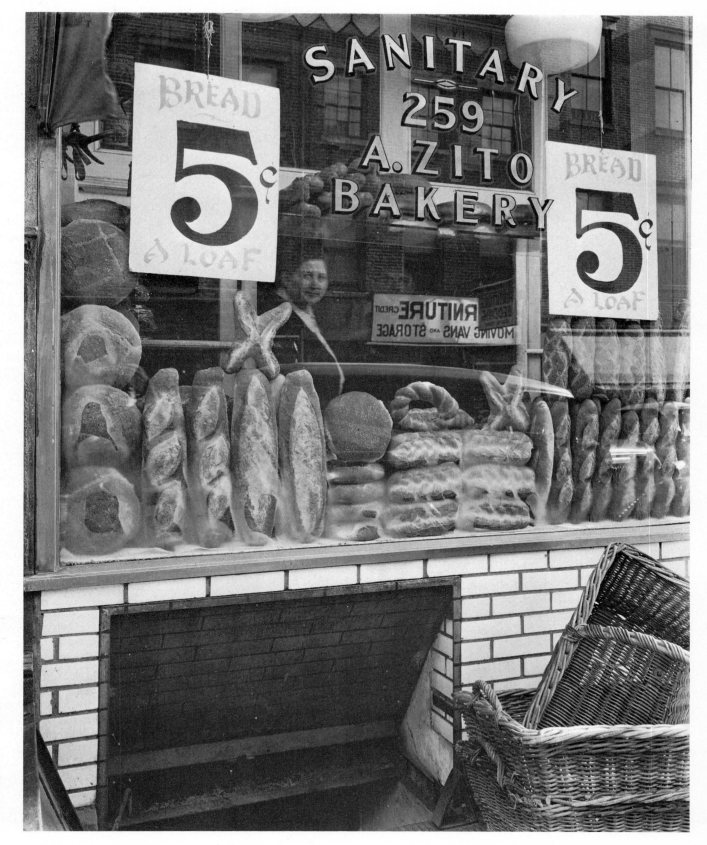

37. BREAD STORE, 259 Bleecker Street, Manhattan; February 3, 1937. Business in existence 20 years.

❦ *Although food chemists believe that bread baked on its own bottom instead of in tins is the healthier food, one now finds only a few bakeshops such as A. Zito's, where the old-fashioned methods are still in use.*

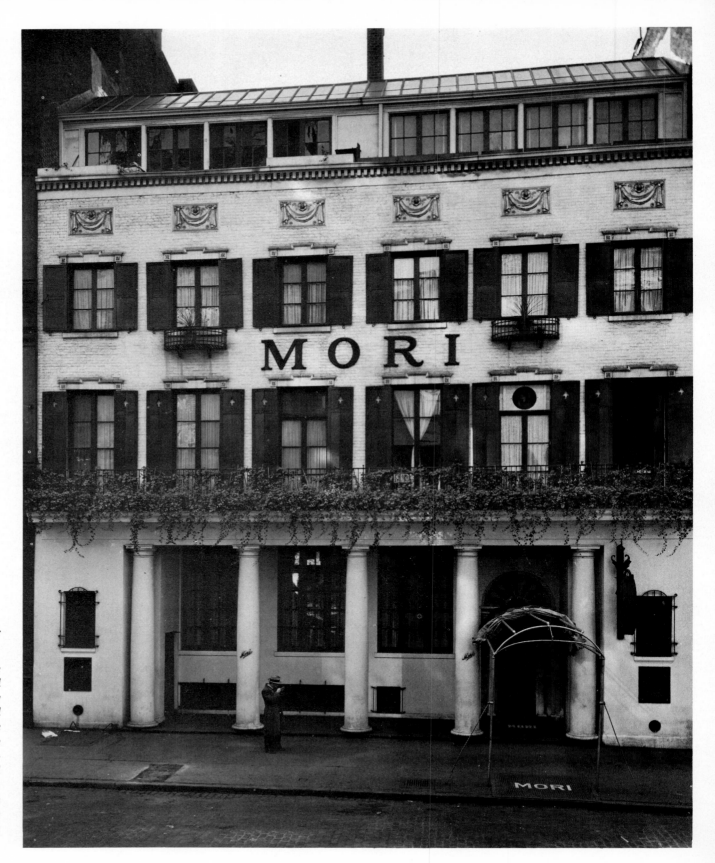

38. MORI RESTAURANT, 144 Bleecker Street, Manhattan; November 21, 1935.

✣ *A "For Rent" sign now decorates the Raymond Hood facade of this once noted Village restaurant. Founded in 1884 by Placido Mori, the restaurant by 1913 had become a landmark, doing a land-office business. Hood, who lived above the Moris on Washington Square North, remodeled the two buildings at 144 and 146 Bleecker Street then, and again in 1919, the latter alteration producing the facade which is so strangely out of place in the shadow of the dingy Sixth Avenue "El."*

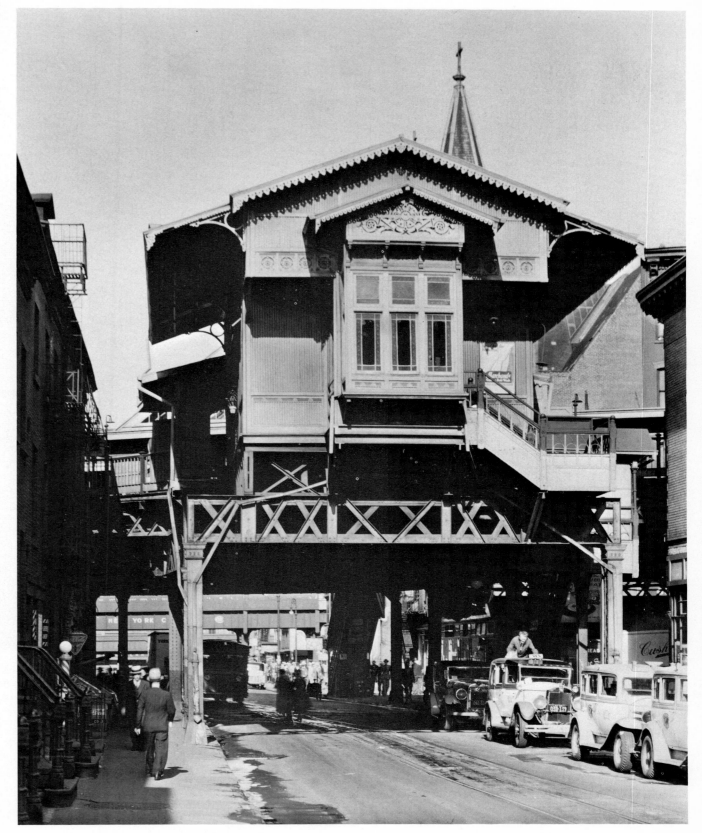

39. "EL" STATION, NINTH AVENUE LINE, Christopher and Greenwich Streets, Manhattan; June 18, 1936. Built: January 31, 1867. Original owner: New York Elevated Railroad Company. Present owner: Interborough Rapid Transit Company.

❧ *A Swiss draftsman, John Hertz, employed in Chief Engineer Courtright's office, contributed the chalet design for this early "El" station. The spreading eaves in the characteristic low-pitched roof are used in Switzerland to keep snow on the roof and so to insulate the interior from winter zero temperatures.*

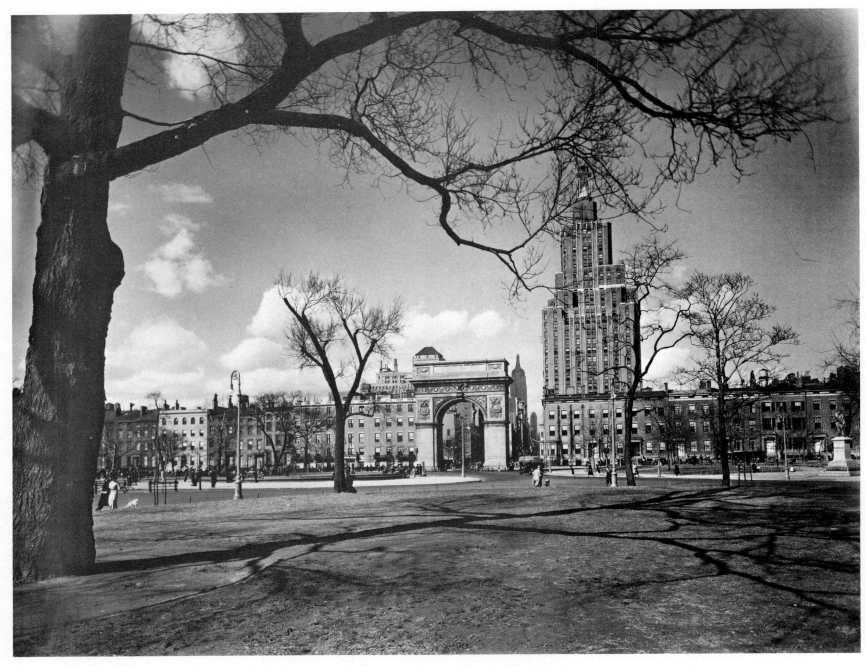

40. WASHINGTON SQUARE, LOOKING NORTH, Manhattan; April 16, 1936. Park created in 1823. Washington Arch erected for the Centennial Celebration of Washington's inauguration as first President of the United States of America. Temporary structure set up in 1889 and paid for by Washington Square residents. Permanent structure completed in 1892 at cost of $125,-000. Architect: Stanford White. Sculpture: Herman A. MacNeil, Frederick W. MacMonnies and A. Stirling Calder.

❧ *Behind the arch the old houses of Washington Square North so far have resisted demolition; but the skyscraper apartment at No. 1 Fifth Avenue symbolizes the fate the old square may look forward to.*

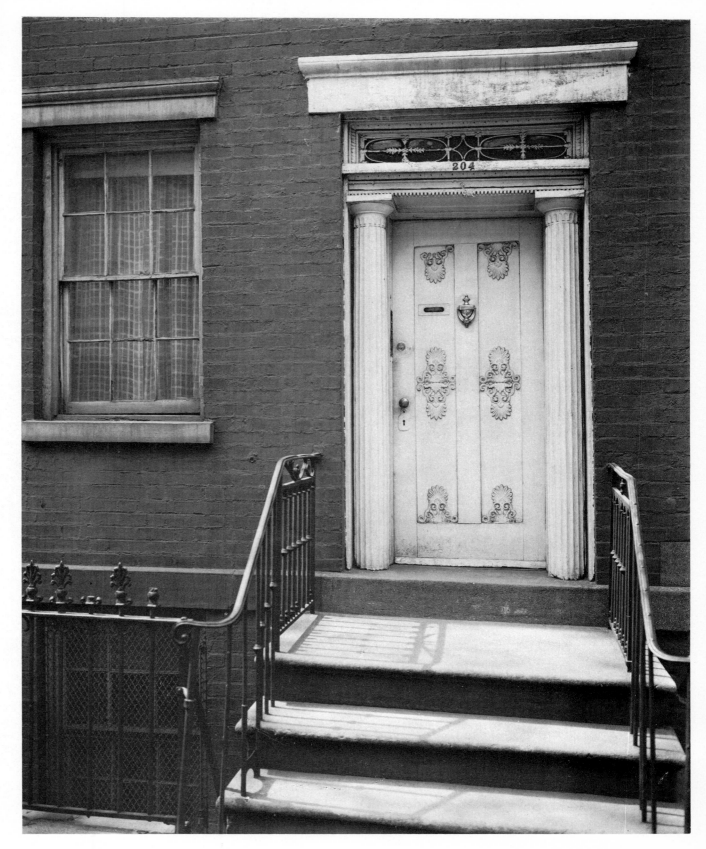

41. DOORWAY: 204 WEST 13th STREET, Manhattan; May 5, 1937.

❧ *The doorway of 204 West 13th Street is one of those chance survivors of a past century whose history is unknown. From early records the houses at this address and at No. 206 appear to have been built in 1841 by "Hans Ditman, artisan." They were then on the outskirts of the young town of Chelsea, started about 1835, as a suburban retreat from the busy, crowded city of New York.*

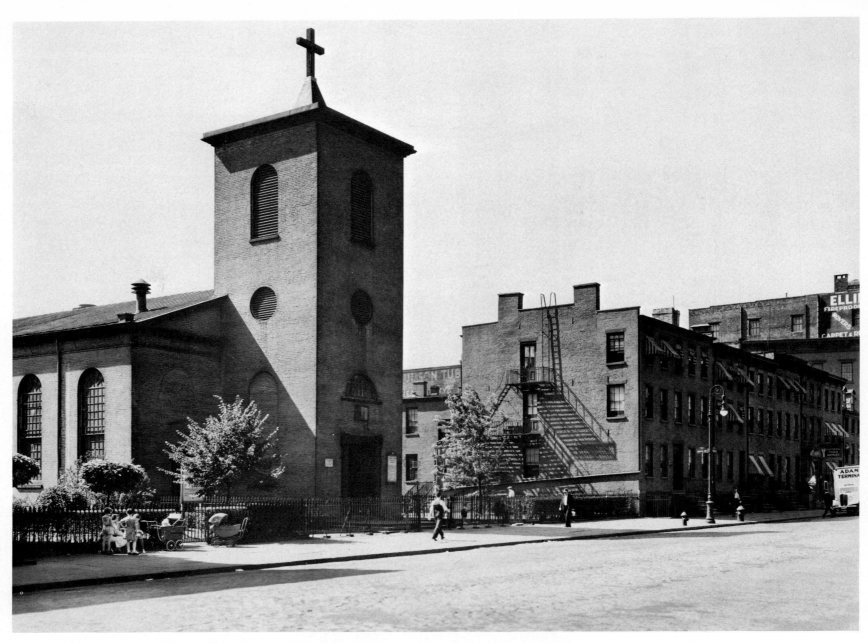

42. ST. LUKE'S CHAPEL AND OLD HOUSES, 483 Hudson Street and 487-493 Hudson Street, Manhattan; June 19, 1936. Cornerstone laid June 4, 1821.

❧ *When New Yorkers who had country homes in Greenwich Village fled thither in 1822 to escape the epidemic ravaging lower Manhattan, they found St. Luke's-in-the-Fields ready to welcome them for worship. Today the chapel is no longer in the fields, but it carries on a custom almost as old as its own physical edifice, the "Leake's Dole." Every Saturday the poor who attend the 10 o'clock service receive free bread, though not precisely the "sixpenny wheaten loaves" of George Leake's will.*

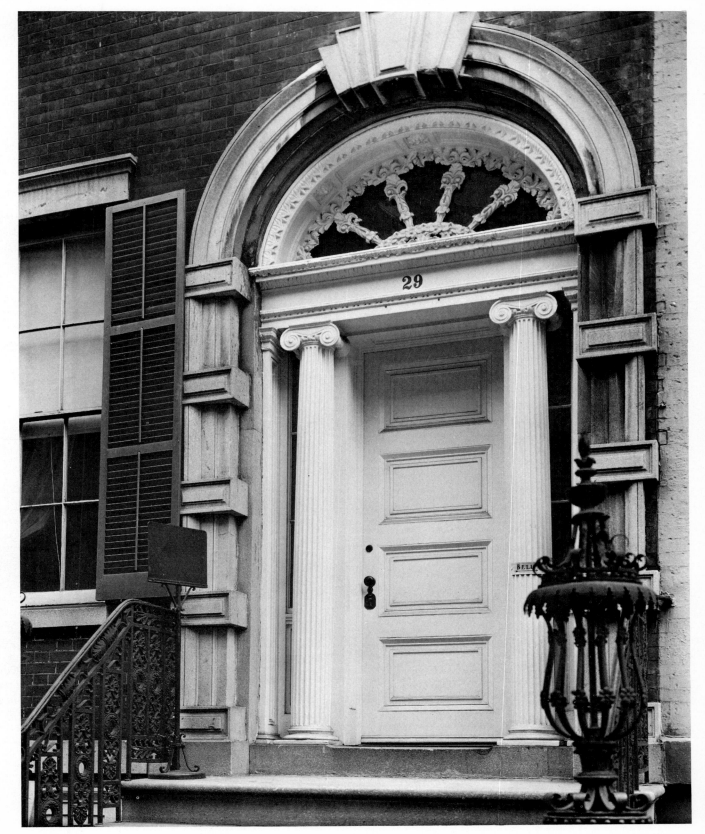

43. DOORWAY: TREDWELL HOUSE, 29 East Fourth Street, Manhattan; September 1, 1937. Built about 1830 for Joseph Brewster from a design attributed to Minard Lafever; sold to Seabury Tredwell in 1835.

❧ *Unchanged since Seabury Tredwell moved in a century ago, the Old Merchant's House on East Fourth Street is the sole surviving example of its type in New York City. Only five years ago the last member of the Tredwell family died; and the house was then saved from demolition by the Historic Landmark Society. The elaborate railings and iron "baskets," the latter used as lights, customarily flanked the entrances of important dwellings in the late 18th and early 19th centuries.*

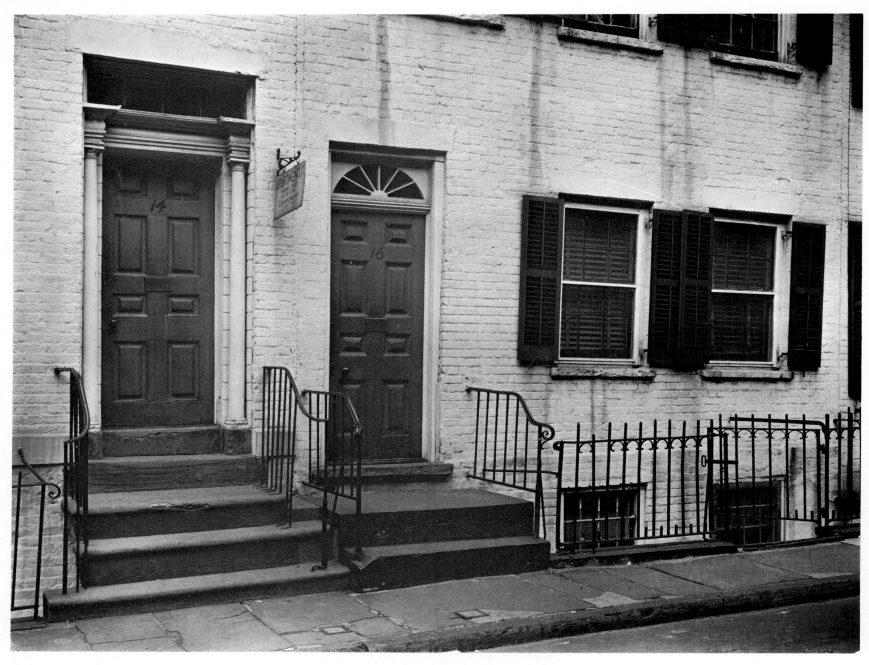

44. GAY STREET, NOS. 14 AND 16, Manhattan; November 16, 1937.

🎄 *Scotch weavers inhabited Gay Street over a century ago. About twenty years ago the one-block street had the distinction of being the only Negro street in the Washington Square neighborhood.*

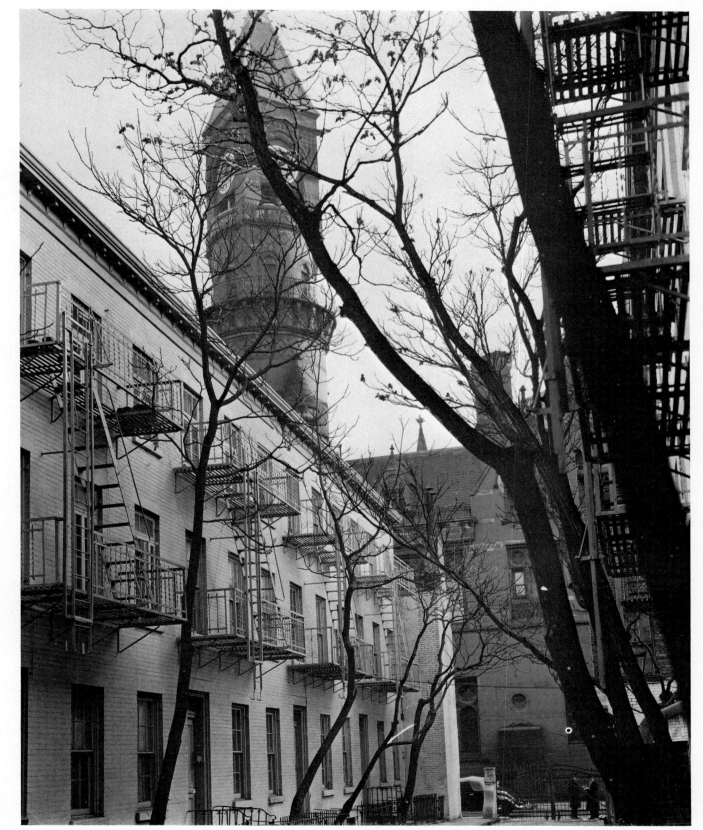

45. PATCHIN PLACE WITH JEFFERSON MARKET COURT IN BACKGROUND, opening off West 10th Street between Sixth Avenue and Greenwich Avenue, Manhattan; November 24, 1937. Land deeded to Aaron D. Patchin by Milligans in 1835.

Jefferson Market Court overlooks ailanthus-lined Patchin Place. Built a century ago, the houses were modernized in 1917. At that time the sanitary conveniences were brought inside, and the yards were drained and cemented. Since then bathtubs, sinks and toilets have been added to all apartments, and electricity and steam heat have been installed. The old gas lamp at the end of the Place was the last object to be brought up to date, being wired for electricity in 1926.

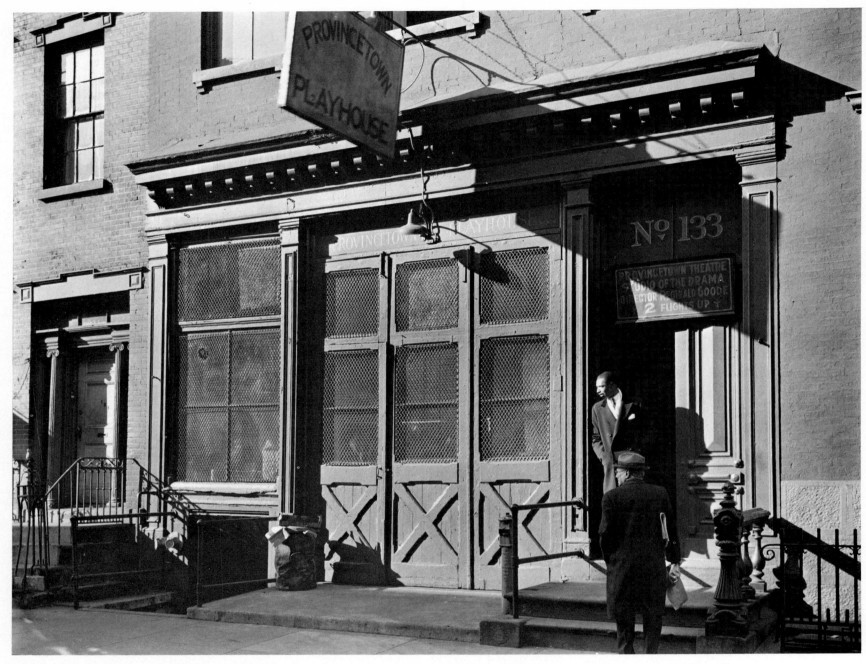

46. PROVINCETOWN PLAYHOUSE, 133 MacDougal Street, Manhattan; December 29, 1936.

❧ *Behind the facade of the Provincetown Playhouse great events in the history of the American theater took place. Organized at Provincetown in 1915, the Provincetown Players found themselves a theater at 139 MacDougal Street in 1916, with the magnificent capital of $320. In 1918 they moved to No. 133, raising $1700 to remodel the former storehouses, stable and bottling works so that it would seat 182. In 1920 the first plaster cyclorama seen on an American stage was constructed there. Closed in 1922, the theater re-opened in 1923, changed management in 1925, and ran till the "crash." Dark from 1930 to 1936, it was again re-opened, this time to house the Studio Theater of the Community Drama Unit of the WPA Federal Theater.*

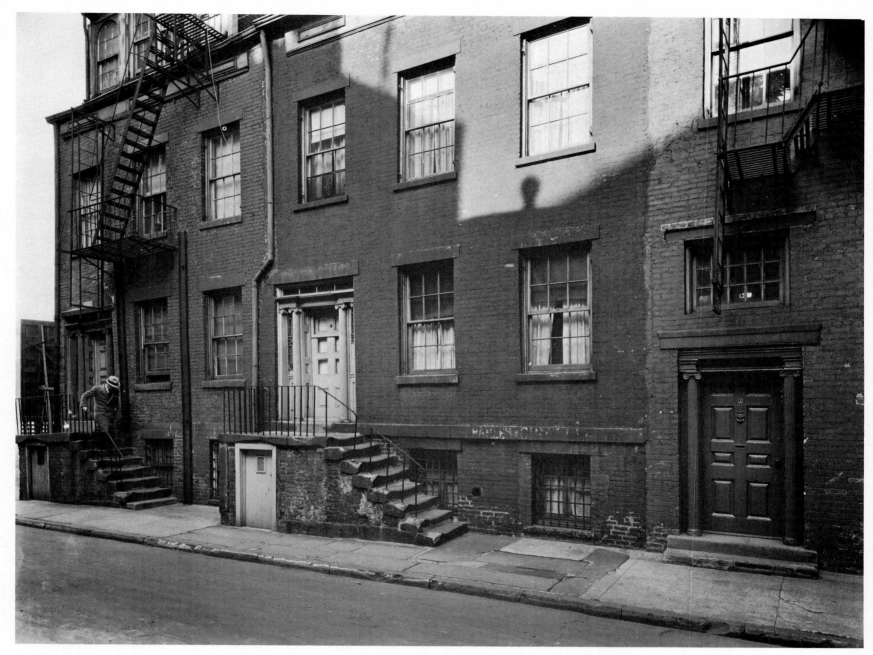

47. MINETTA STREET, NOS. 2, 4, 6, Manhattan; November 21, 1935. Present owner: Mutual Life Insurance Company.

❧ *Where the trout stream Minetta Brook once ran, these houses stood till 1936. Built between 1800 and 1807, they were probably the homes of artisans excluded from the then fashionable Varick Street. By the early '00s they had become ragpickers' storehouses. In 1913 they were restored and occupied as private dwellings. In 1924, Nos. 2 and 6 were remodeled into two-family houses. And in 1936 they were demolished.*

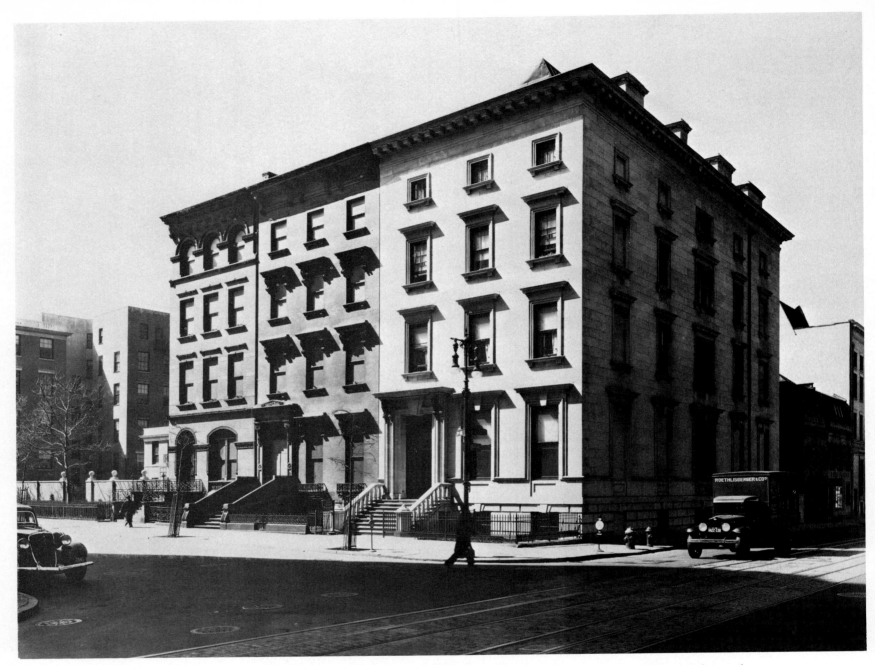

48. FIFTH AVENUE, NOS. 4, 6, 8, Manhattan; March 6, 1936. Built in 1886, 1887 and 1888 for Mrs. Mary Wetherbee, Mrs. Rhinelander Stewart and Mrs. J. Herbert Johnston.

Built in the mid-eighties for three Rhinelander daughters, the houses at the southwest corner of Fifth Avenue and Eighth Street present a rising curve of elegance. Henry J. Hardenbergh, architect of the old Waldorf-Astoria, the Hotel Albert and the Third Avenue Car Barns, designed all three. No. 8 was once the home of the art collection which formed a part of the original Metropolitan Museum of Art.

49. CIVIC REPERTORY THEATRE, 105 West 14th Street, Manhattan; July 2, 1936. Built in 1866.

❧ *Edwin Forrest, Laura Keene, Edwin Booth, Modjeska, Eva Le Gallienne and the Labor Theater all played behind this Corinthian portico. From its opening in 1866, when French drama and Italian opera held the stage, till its demolition in 1938, the Théâtre Français (later the 14th-Street Theater) lived through the cycle of theatrical history, welcoming "Camille," "Richelieu," "The Old Homestead," the classic revivals of the Civic Repertory Company, and "Let Freedom Ring."*

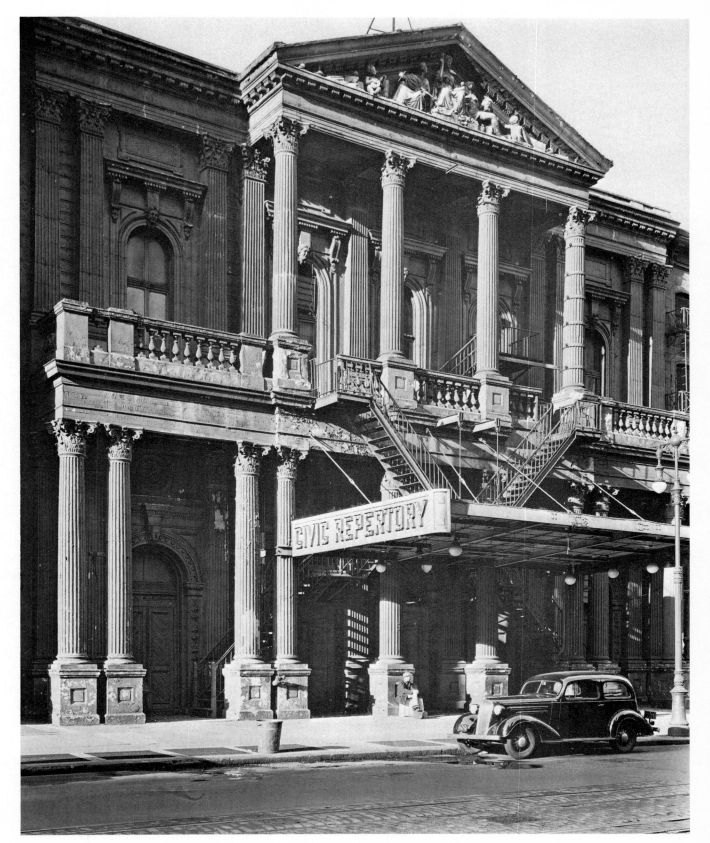

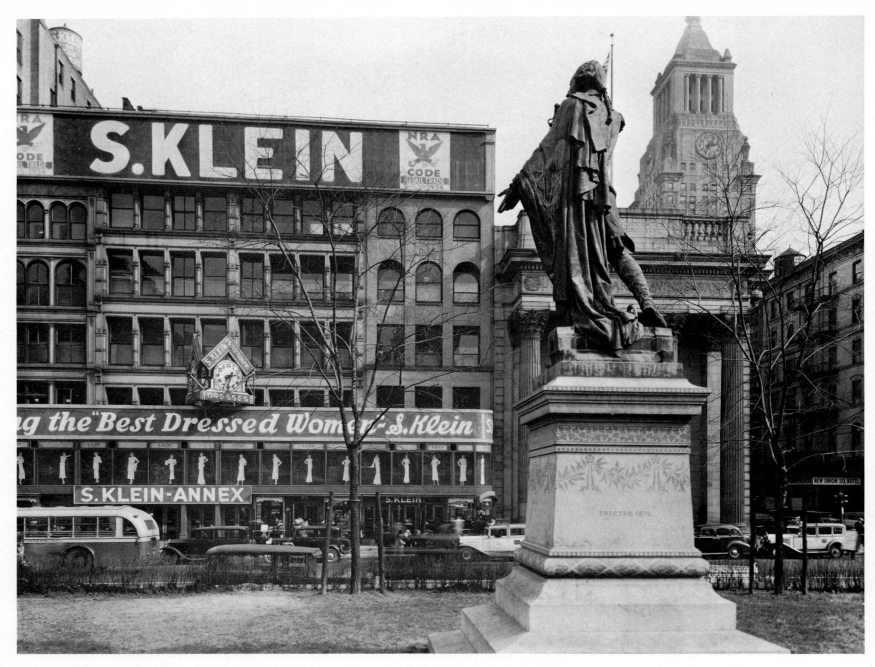

50. UNION SQUARE, Manhattan; March 20, 1936. Statue of Lafayette by Frédéric A. Bartholdi (1834-1904), erected in 1876 by the Republic of France.

❧ Union Square is historical for other reasons than the May Day parades and labor demonstrations now held there. It is first heard of by name in 1811, when surveys showed it as planned to extend from 10th Street to 17th Street. In the middle 19th century it was a fashionable residential district, and later, a center of hotels and theaters. S. Klein founded his business in 1912 and it is still under the direction of the original owner.

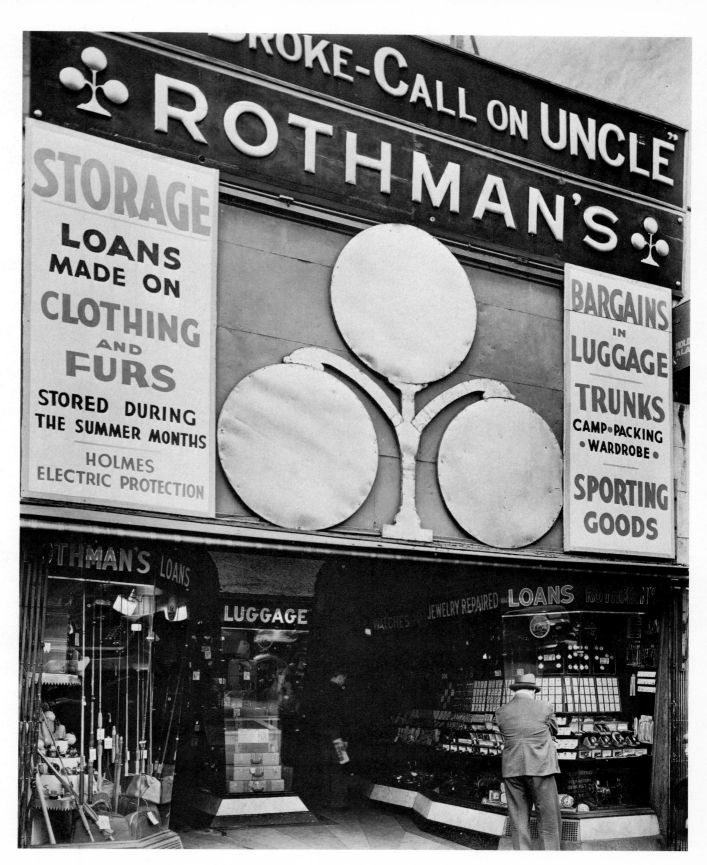

51. ROTHMAN'S PAWNSHOP, 149 Eighth Avenue, Manhattan; May 18, 1938. Business started in 1883 at 443 Canal Street.

❧ *The pawnbroking business is as carefully regulated by law as food peddling. Pawnbrokers are required to post a $10,000 bond and to pay a yearly license fee of $500. Interest rates are determined by law, and pawnbrokers must carry insurance on objects on which they make loans.*

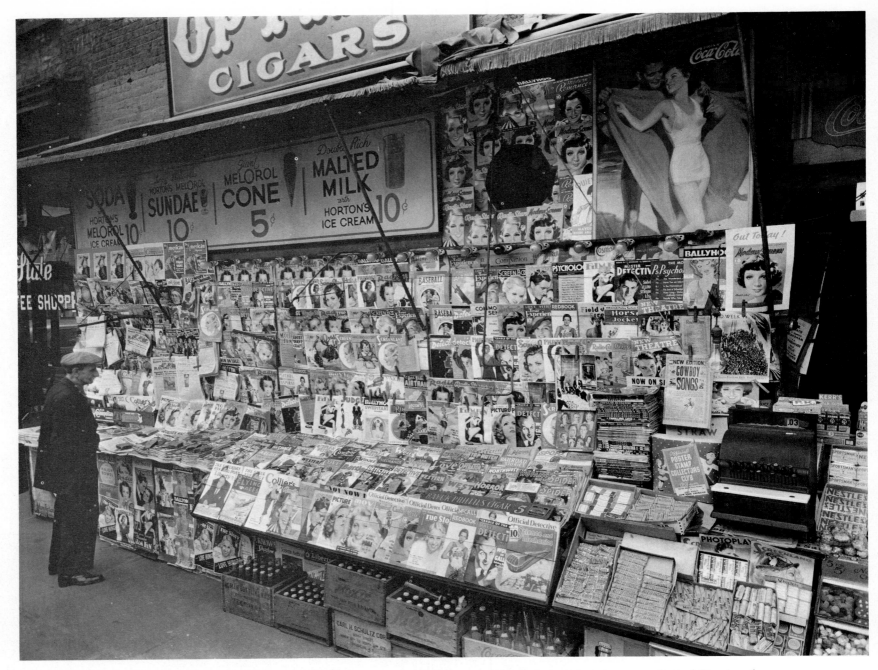

52. NEWSSTAND, southwest corner of 32nd Street and Third Avenue, Manhattan; November 19, 1935. Built in 1932 by James Stratakos and still owned and operated by him.

❧ *The newsstand at the southwest corner of 32nd Street and Third Avenue is typical of what the public reads. Over 200 magazines are handled, but it is sales from the metropolitan daily newspapers which keep the business going.*

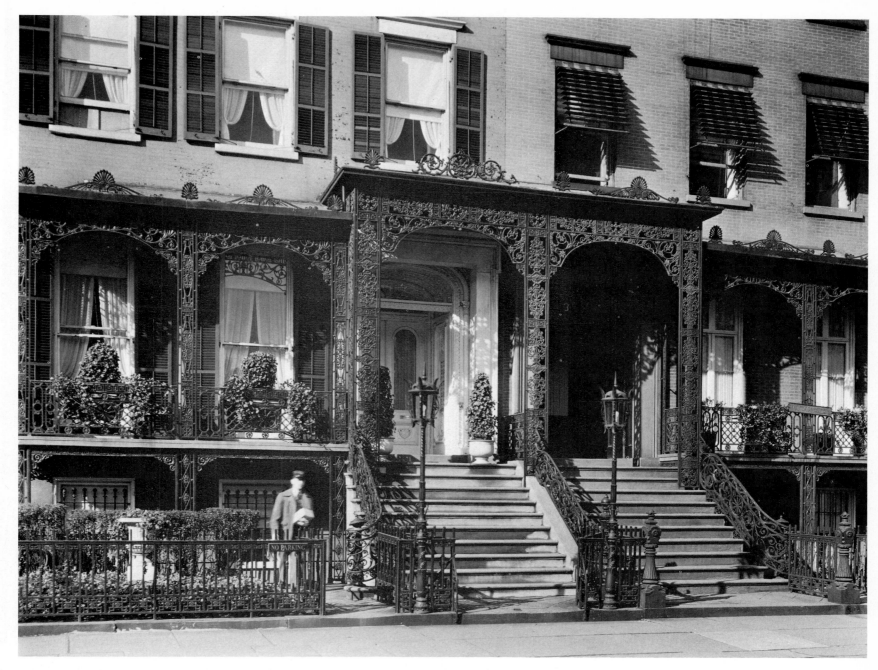

53. GRAMERCY PARK WEST, NOS. 3 AND 4, Manhattan; November 27, 1935. Built: 1845 by Norman Davis. Architect: probably Alexander Jackson Davis.

❧ *James Harper, Mayor of New York from 1844 to 1847 and a founder of J. & J. Harper, publishers, lived at No. 4 Gramercy Park West which he bought in 1848, until 1869. The "Mayor's Lamps" at the entrance were installed at the time he took up residence here. The custom dates from early Dutch days when lanterns were placed outside the homes of city officials. With each new mayor another pair of lamps appears; and the old ones are left burning wherever former mayors or their descendants live.*

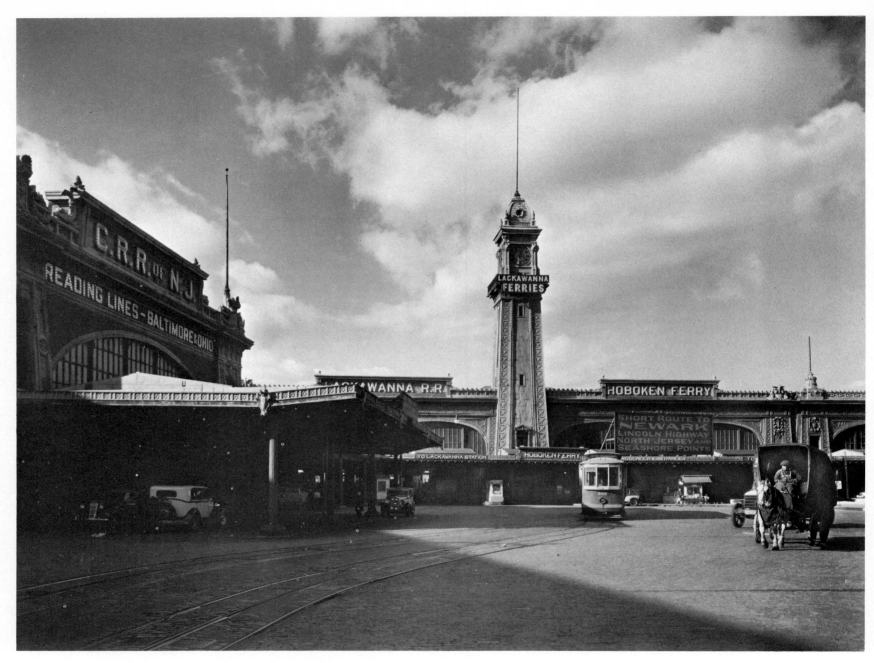

54. FERRIES, FOOT OF WEST 23rd STREET, Manhattan; December 23, 1935. Built in 1907. Architect: Kenneth Marchison. Designer of train sheds: L. Bush. Originally owned by Hoboken Steamboat Ferry Company; now by New York City, under the supervision of the Department of Docks, Bureau of Ferries.

✺ *Built thirty years ago, the West 23rd-Street Ferry Station suggests an older period. A ferry has been operated on its site since Revolutionary times.*

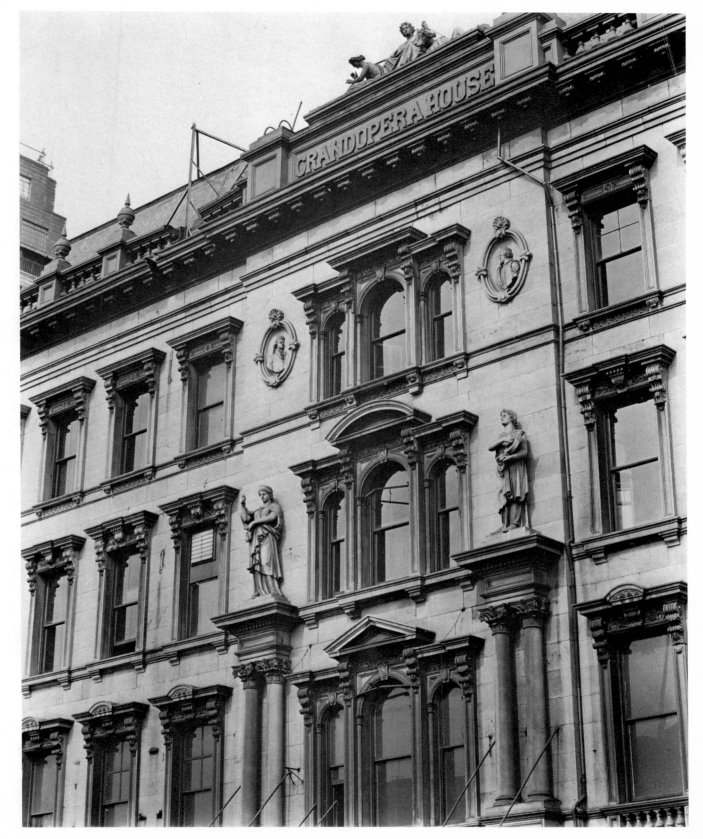

55. GRAND OPERA HOUSE, northwest corner of West 23rd Street and Eighth Avenue, Manhattan; August 12, 1936. Opened in 1867 as Pike's Opera House.

❧ *Today this building houses a movie theater; and its ground-floor facade has been extensively remodeled with chromium and plate glass. The two statues flanking the entrance have vanished in the course of remodeling, carrying away the last vestiges of its heyday as the plaything of railroad magnate Jim Fisk.*

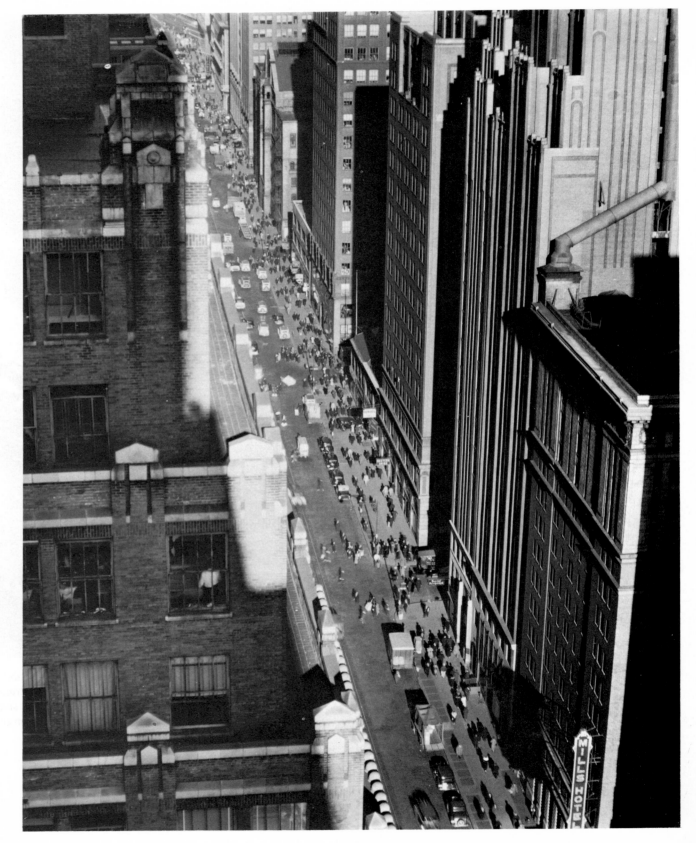

58. SEVENTH AVENUE, LOOKING NORTH FROM 35th STREET, Manhattan; December 6, 1935. The buildings shown on the east side of Seventh Avenue, beginning with the Mills Hotel at 36th Street and continuing to the Metropolitan Opera House at 39th Street, have a total assessed valuation of almost $14,-000,000.

❧ *Since the garment manufacturers moved uptown and west in 1917, Seventh Avenue has become the home of skyscrapers, the Garment Tower, the Garment Center and the Fashion Center among them. A Mills Hotel is at the extreme right and the Metropolitan Opera House almost at the end of the street. The tiny low building about in the center of the picture is the former stable of the Wendel mansion on Fifth Avenue.*

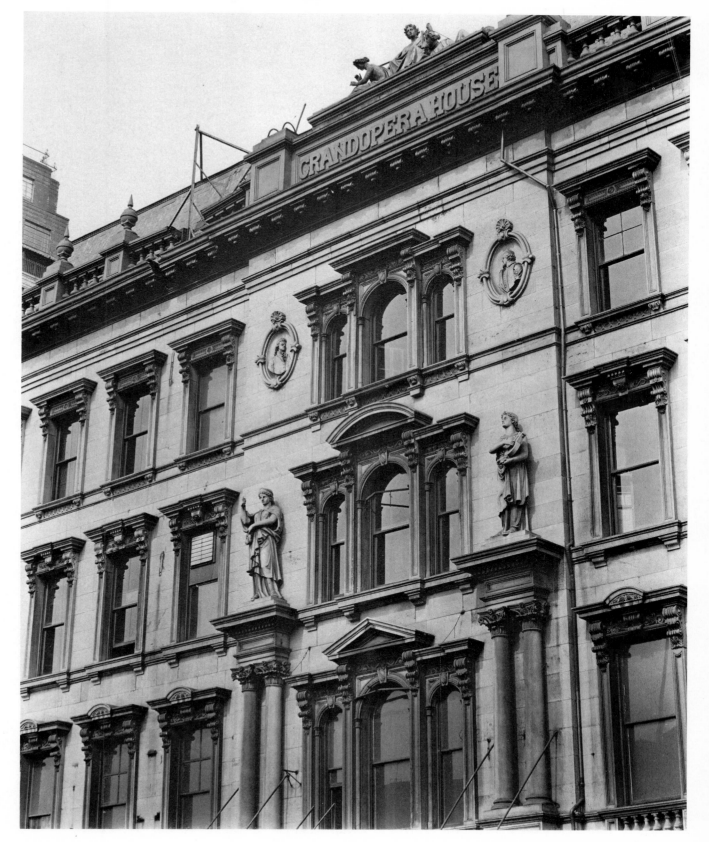

55. GRAND OPERA HOUSE, northwest corner of West 23rd Street and Eighth Avenue, Manhattan; August 12, 1936. Opened in 1867 as Pike's Opera House.

❧ *Today this building houses a movie theater; and its ground-floor facade has been extensively remodeled with chromium and plate glass. The two statues flanking the entrance have vanished in the course of remodeling, carrying away the last vestiges of its heyday as the plaything of railroad magnate Jim Fisk.*

56. FLATIRON BUILDING, Broadway and Fifth Avenue between 22nd and 23rd Streets, Manhattan; May 18, 1938. Built: 1902. Architect: Daniel H. Burnham.

❧ *Accident led to the construction of the Flatiron Building. Winfield A. Stratton, a Colorado gold miner, had struck it rich and planned to build "the most noble" residence in America at Cripple Creek. Going to Chicago to commission an architect, he met Daniel H. Burnham and George A. Fuller, who persuaded him to build the tallest office building in the country at that time, 1902. The triangular site produced a building severely criticized by contemporary writers.*

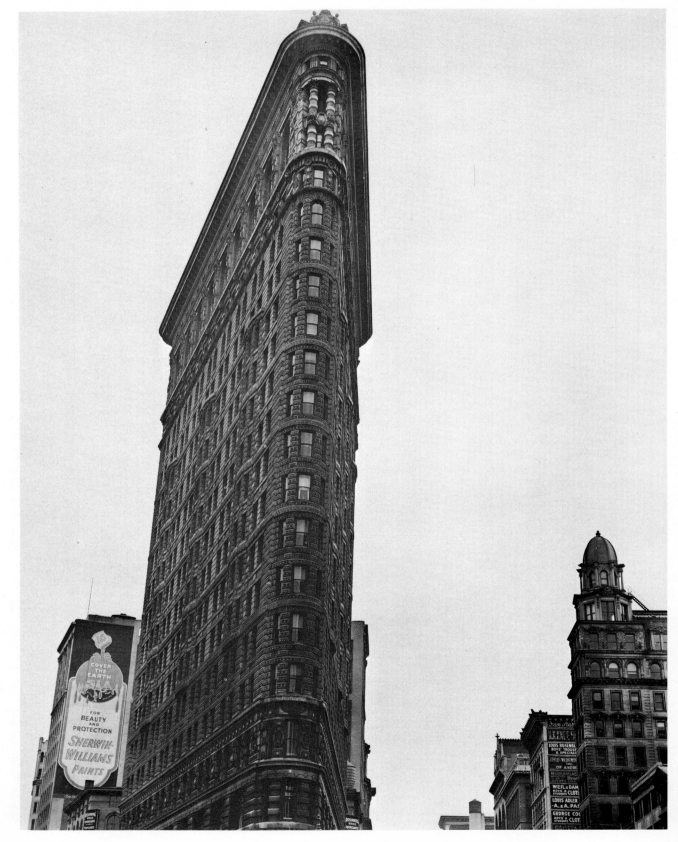

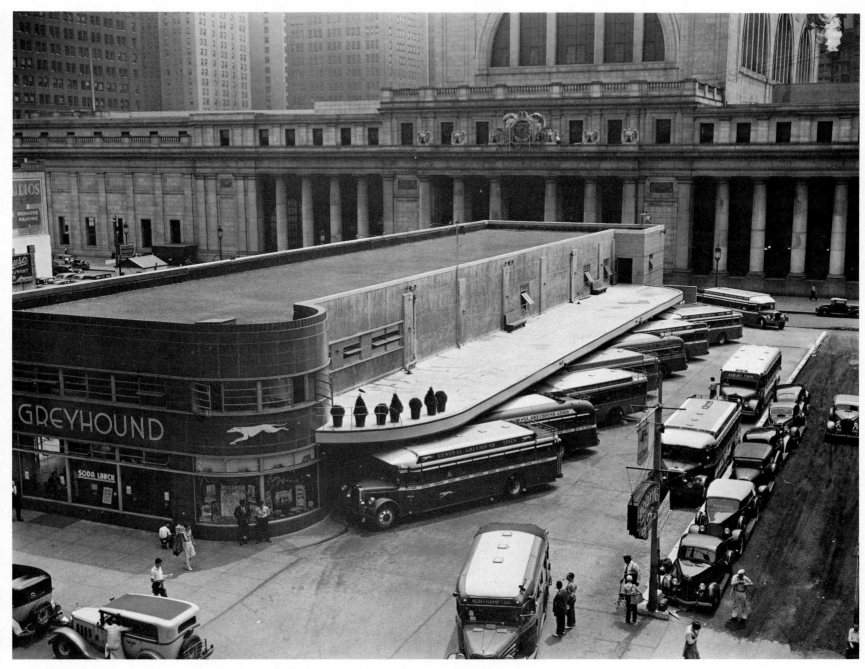

57. GREYHOUND BUS TERMINAL, 244-248 West 34th Street and 245-249 West 33rd Street, Manhattan; July 14, 1936. Built: 1935. Architect: Thomas W. Lamb, Inc. Owned by Hotel Statler Company, Inc.

❧ *Characteristic of the flexibility and small overhead expense of bus lines as against rail transportation are the several terminals in the midtown district, some specially constructed, some in the ground-floor spaces of large office buildings.*

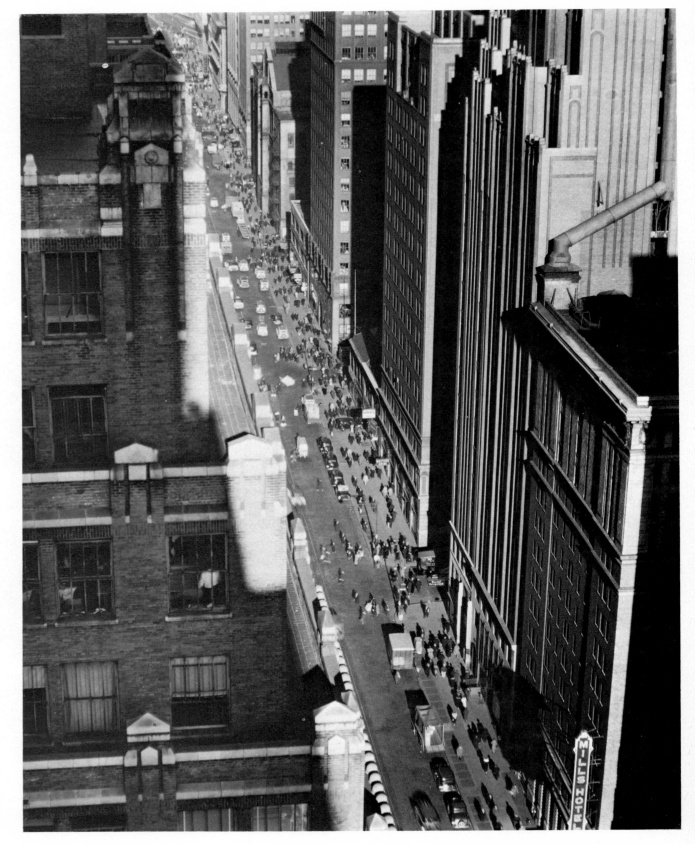

58. SEVENTH AVENUE, LOOKING NORTH FROM 35th STREET, Manhattan; December 6, 1935. The buildings shown on the east side of Seventh Avenue, beginning with the Mills Hotel at 36th Street and continuing to the Metropolitan Opera House at 39th Street, have a total assessed valuation of almost $14,-000,000.

❧ *Since the garment manufacturers moved uptown and west in 1917, Seventh Avenue has become the home of skyscrapers, the Garment Tower, the Garment Center and the Fashion Center among them. A Mills Hotel is at the extreme right and the Metropolitan Opera House almost at the end of the street. The tiny low building about in the center of the picture is the former stable of the Wendel mansion on Fifth Avenue.*

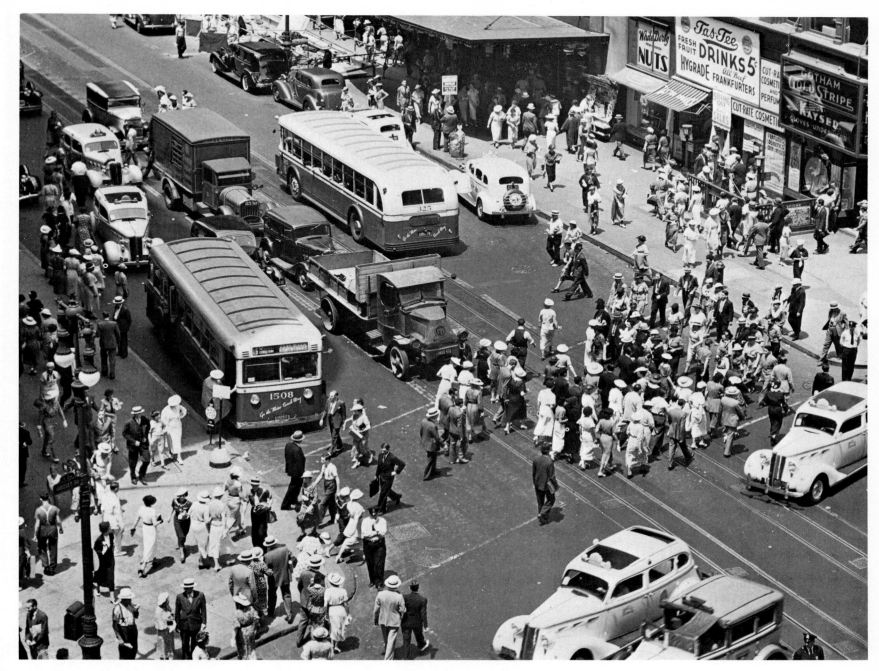

59. HERALD SQUARE, Manhattan; July 16, 1936.

Underground, Herald Square is the most involved traffic intersection in the world. Long Island tubes of the Pennsylvania, the new Sixth Avenue line of the Independent Subway, the B.M.T. and the Hudson Tubes cross one and another at varying angles and depths to 65 feet. Surface traffic recently lost the streetcars and the rumble of the "El" has barely ceased; but buses, taxis, private autos, trucks and pedestrians jam the square. A network of water mains, gas and electric conduits, telephone and telegraph wires, and sewers complete the tangle.

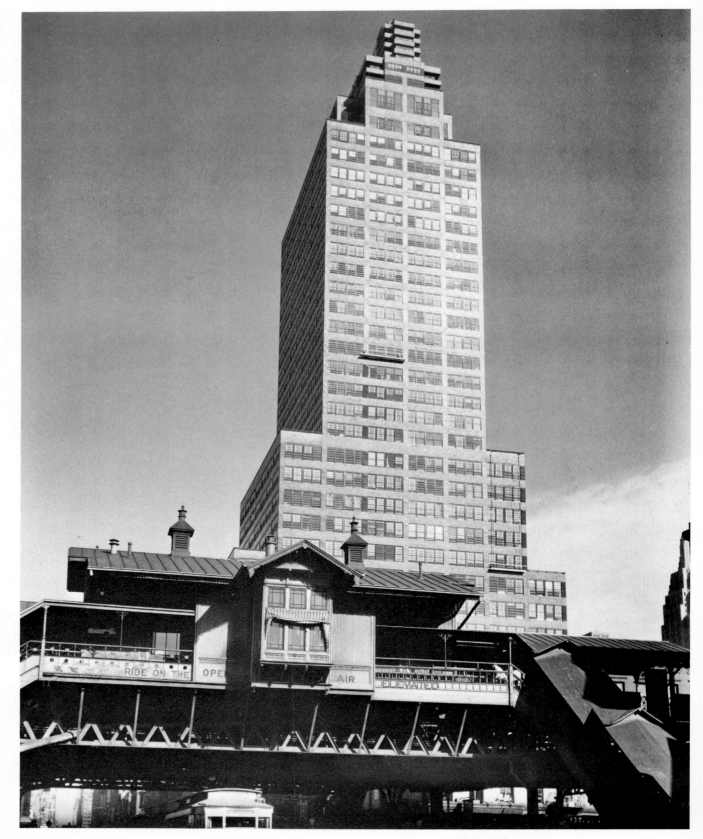

60. McGRAW-HILL BUILDING, 330 West 42nd Street, Manhattan; May 25, 1936. Architects: Hood & Fofor.

❧ *The glazed blue-green terra-cotta, steel and glass of the McGraw-Hill Building present a clear example of the functional type of architectural design. If architecture is "the business of manufacturing shelter," then (argued Raymond Hood) the building must efficiently house the huge scientific publishing business. Maximum utilization of light and air was required; hence the generous use of glass.*

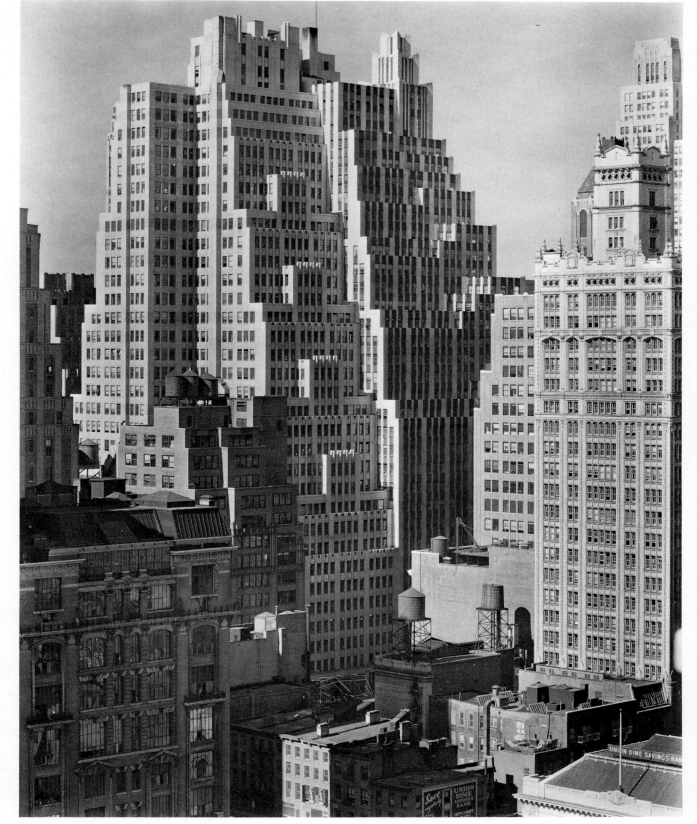

61. FORTIETH STREET BETWEEN SIXTH
AND SEVENTH AVENUES, from Sal-
mon Tower, 11 West 42nd Street, Man-
hattan; December 8, 1938.

☘ *Fortieth Street, Sixth Avenue and
Broadway mingle in the architectural
cascade seen from the Salmon Tower.
The historic Bryant Park Studio Building
at the left and the World Tower Build-
ing at the right frame modern setback
skyscrapers of a later generation, the
Bricken Casino and 1400 Broadway. The
low structures in the foreground on Sixth
Avenue are about a century old, typical of
the changing city.*

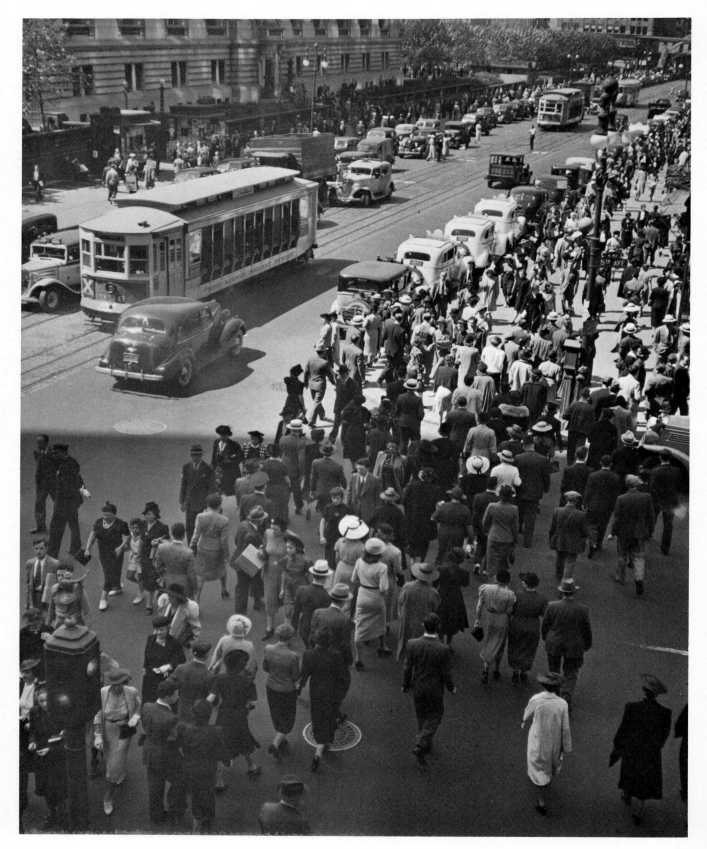

62. TEMPO OF THE CITY, Fifth Avenue and 42nd Street, looking west from Seymour Building, 503 Fifth Avenue, Manhattan; September 6, 1938.

❧ *A quarter of a million people sweep past this intersection every 24 hours— not as vast a tide as the human eddies of the great squares, Times, Herald, Madison, Union, but a great maelstrom of activity nevertheless. Peak hour is 5 to 6 p.m., when 30,000 human beings crowd this corner, and 3500 vehicles pass.*

63. MURRAY HILL HOTEL: SPIRAL, 112 Park Avenue, Manhattan; November 19, 1935. Built: 1884. Designed by John D. Hatch.

✦ *Headquarters of James G. Blaine in the 1884 presidential campaign, the Murray Hill Hotel was one of the most magnificent examples of hotel architecture of the brown decades. The elegant iron spiral balconies came from the Daniel D. Badger works, but are probably the design of Oscar Luetke, connected with the firm at the time.*

64. PARK AVENUE AND 39th STREET, Manhattan; October 13, 1936. Set up temporarily in 1936 as a demonstration of modern architectural style and steel panel construction. Architect: William Van Alen of Chrysler Building fame. Owner: National Houses, Inc.

❧ *Built on a $1,000,000 lot at a cost of $10,000, the "House of the Modern Age" briefly dazzled Park Avenue traffic. Thousands of people paid ten cents each to see its smart and efficient interior and then it was taken down.*

65. "DAILY NEWS" BUILDING, 220 East 42nd Street, Manhattan; November 21, 1935. Completed: February, 1930. Architects: Howells, Hood & Fouilhoux. Owned by News Syndicate Company, Inc.

☙ Three million circulation Sundays, one and three-quarter million weekdays—more than double that of the next largest American newspaper—this is the Daily News. Such revenue made possible "The House that Tabloid Built," the Daily News Building, a 36-story skyscraper, costing $10,000,000.

66. GLASS-BRICK AND BROWNSTONE FRONTS, 211 and 209 East 48th Street, Manhattan; February 1, 1938. Present owners: William Lescaze and Timothy Murphy.

❧ *One Charles Cheseborough built two brownstones in about 1860 of almost identical form; and in 1934, William Lescaze remodeled No. 211 to produce the first glass-brick front for residential purposes in New York City. The neighborhood is now extending the fashion, both on East 48th Street and on East 49th.*

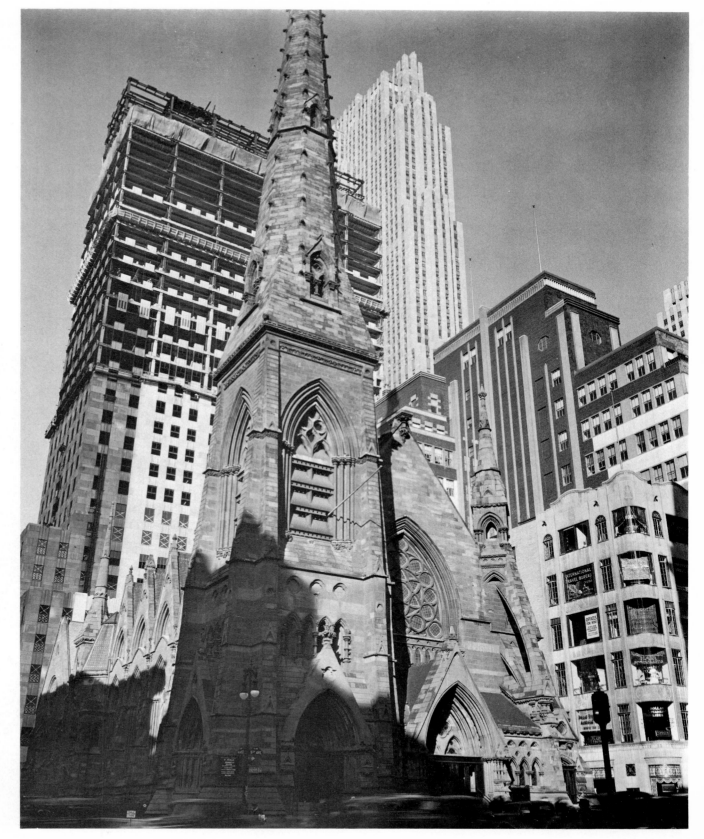

67. ROCKEFELLER CENTER WITH COLLEGIATE CHURCH OF ST. NICHOLAS IN FOREGROUND, Fifth Avenue and 48th Street, Manhattan; December 8, 1936. Cornerstone laid 1869. Architect: W. Wheeler Smith.

❧ *The Collegiate Church of St. Nicholas at Fifth Avenue and 48th Street was pronounced by the late Dean Stanley of the Church of England to be the finest piece of ecclesiastical architecture he had seen in America. Rising above it, the steel skeleton of Rockefeller Center's Time & Life Building and the white tower of the RCA Building are a dramatic index of change in the metropolis.*

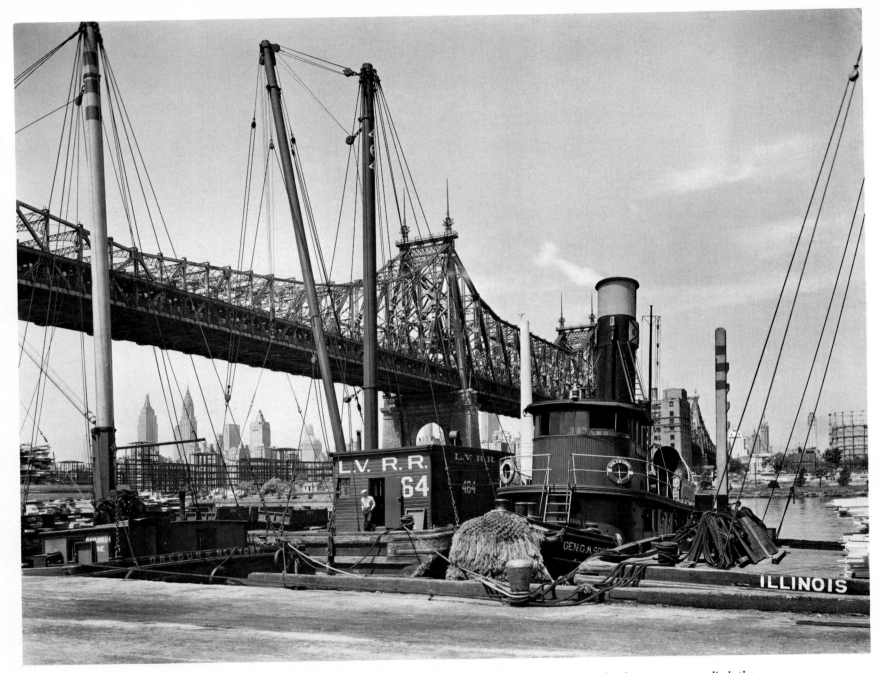

70. QUEENSBORO BRIDGE, looking southwest from pier at 41st Road, Long Island City, Queens; May 25, 1937. Bridge, only cantilever in New York City, extends from 59th and 60th Streets, Manhattan, to Crescent Street, Long Island City. Crosses Welfare Island, formerly Blackwell's Island, from which bridge first took its name. Designed by F. C. Kunz, chief engineer. Begun in 1903, completed in November, 1908. Built by New York City Department of Bridges; now under Public Works Department.

❧ Thirty years have passed since bridge experts studied the loads and stresses which could be sustained by the Queensboro Bridge. Cantilever bridges were under suspicion then because the Quebec Bridge had fallen. A large margin of safety was allowed by increasing the weight of the steel structure 25 per cent. The bridge still carries its burden of subway tracks and surface car tracks, footwalks and automobile roadways, apparently safely.

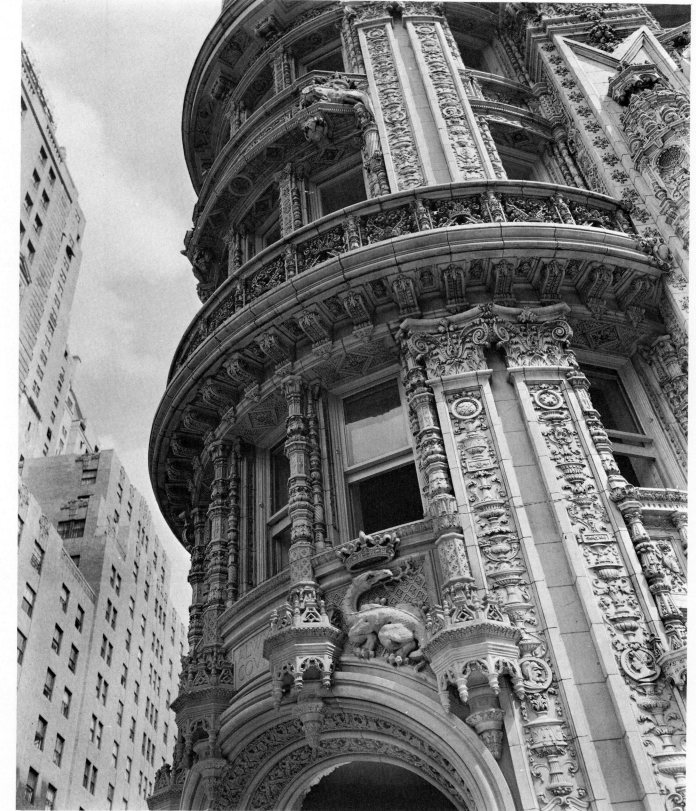

71. FACADE, ALWYN COURT, 174-182 West 58th Street and 911-917 Seventh Avenue, Manhattan; August 10, 1938. Built in 1907-8. Architect: Harde & Short.

❧ *Built in 1908, Alwyn Court has already suffered the rapid obsolescence of buildings in the metropolis. The most luxurious apartment house of its day, it provided a separate conservatory and wine cellar for each tenant, with suites numbering 13 and 14 rooms. The original cost was $900,000; and after foreclosure in 1936, it was completely remodeled in 1938 into 3-and 4-room apartments at a cost of $400,000 to $500,000. Only its outer shell was left intact—with the heraldic salamanders of Francis I.*

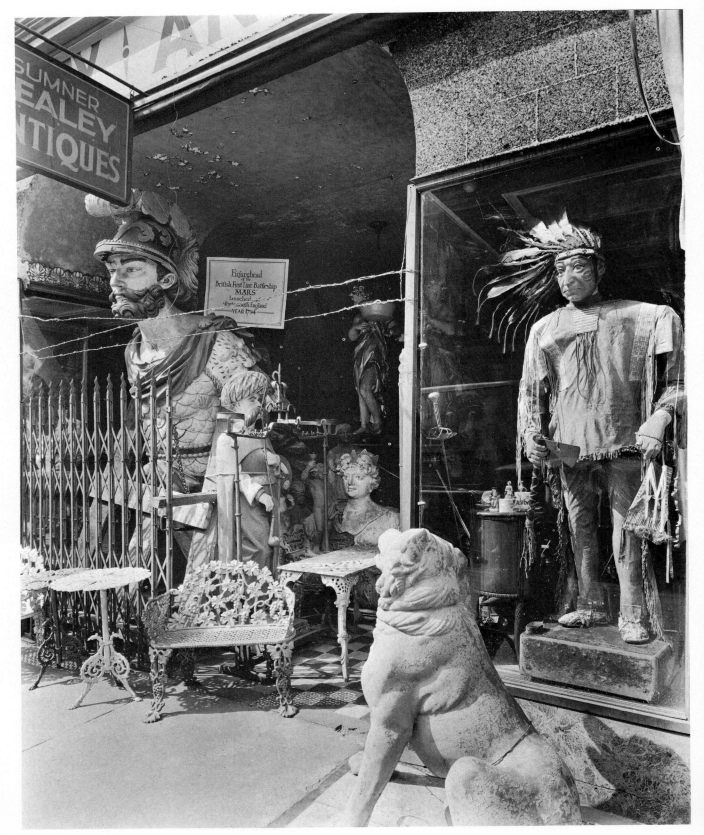

72. SUMNER HEALEY ANTIQUE SHOP, 942 Third Avenue, Manhattan; October 8, 1936.

❦ *Change in the city has swept Sumner Healey's extraordinary montage of antiques into the discard. Moving in 1932 to Third Avenue from its long-established site on Lexington, the shop weathered the death of its founder in 1936, soon after the photograph was taken, but by the summer of 1938 a "For Rent" sign hung in the windows. The antiques here portrayed had long since been dispersed, to Ticonderoga, Long Island and the Middle West.*

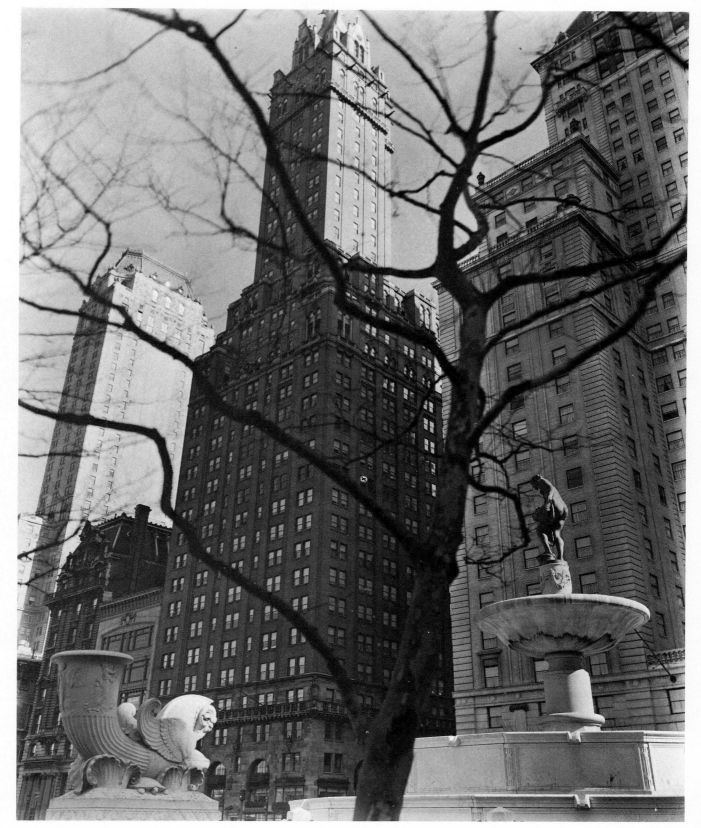

73. CENTRAL PARK PLAZA, from Fifth Avenue and 58th Street, Manhattan; March 2, 1937. Architects: Schultze & Weaver; McKim, Mead & White; Carrerre & Hastings. Sculptor of fountain: Karl Bitter. Built in 1930, 1928, 1927 and 1916.

❧ *The elegant millions of the Hotels Pierre, Sherry-Netherland and Savoy-Plaza look down on the comparatively modest Fountain of Abundance where, in the shadow of the Plaza Hotel which still maintains much of its old eminence, a center of ultra-costly residential hotels has arisen.*

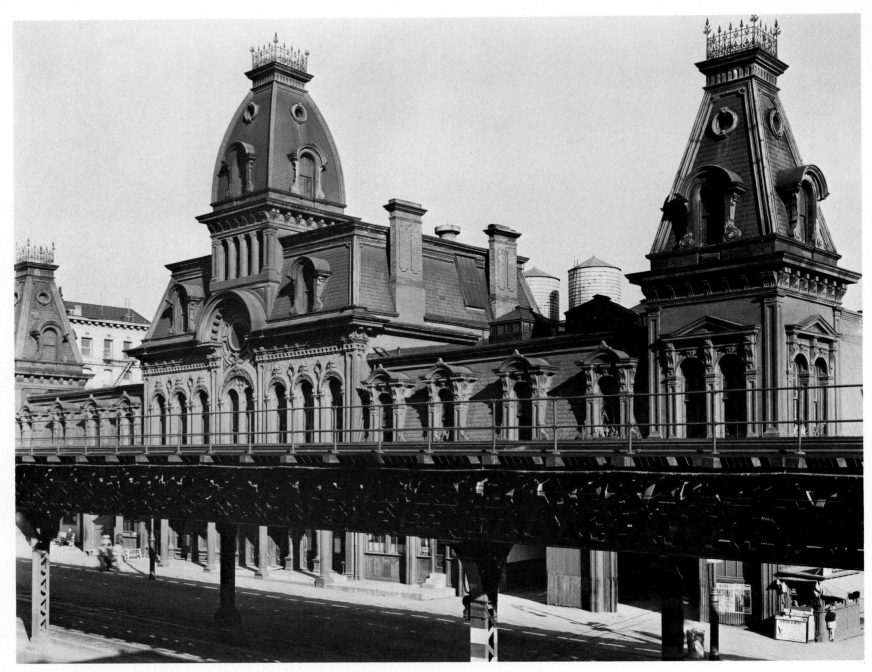

74. THIRD AVENUE CAR BARNS, Third Avenue between 65th and 66th Streets, Manhattan; October 13, 1936. Built: 1896. Architect: Henry J. Hardenbergh. Owned by Third Avenue R. R.

"The mansard roof and towers and elaborated window detail all seem to have found in this purely utilitarian structure free expression of the French influence which characterized Hardenbergh's best known work," wrote Royal Cortissoz, a quarter of a century ago, probably having in mind the old Waldorf-Astoria Hotel, which this architect also designed. Today the building still houses streetcars, the last car barn in use in the city.

75. COURT OF THE FIRST MODEL TENE-
MENT IN NEW YORK CITY, 361-365
71st Street, 1325-1343 First Avenue, and
360-364 72nd Street, Manhattan; March
16, 1936. Built: 1882. Architects: Vaux
& Radford.

❧ *The decade 1880–1890 saw the "model
tenement" movement arise in the Im-
proved Dwellings Association and the
Tenement House Building Company. The
minimum specifications of sixty years
ago are no longer "model," in fact, they
verge on illegality. But at the time of
their erection, these buildings represented
a definite advance toward the humane in
New York's still present housing prob-
lems.*

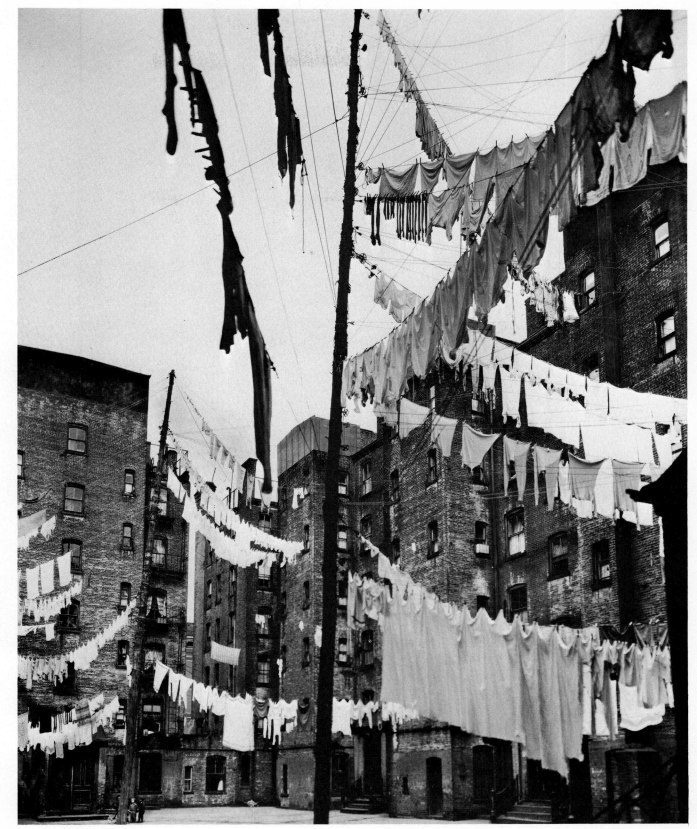

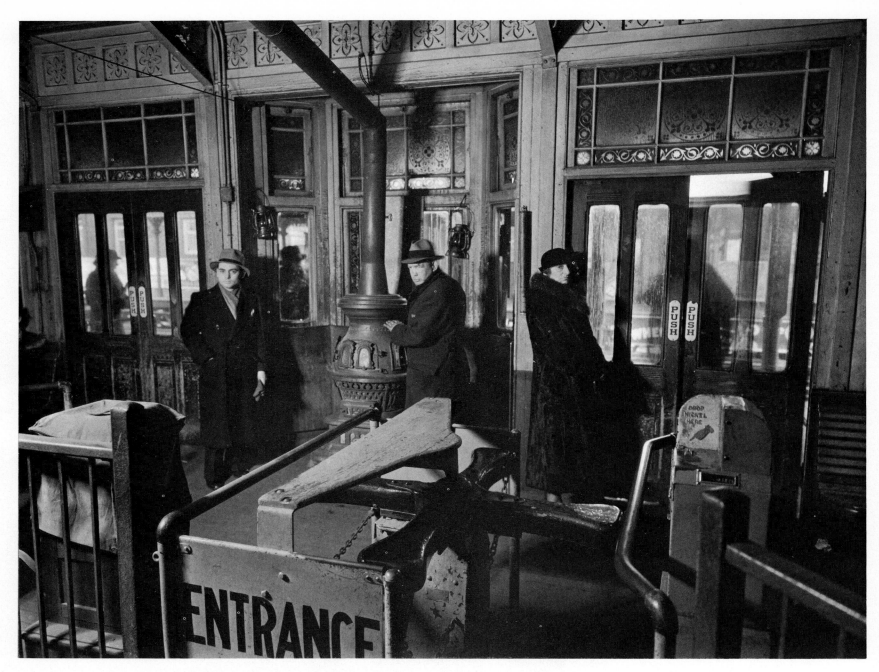

76. "EL" STATION INTERIOR, SIXTH AND NINTH AVENUE LINES, DOWNTOWN SIDE, Columbus Avenue and 72nd Street, Manhattan; February 6, 1936. Original owner: Gilbert Elevated Railway Company. Present owner: Interborough Rapid Transit Company.

❧ *Unaltered, except for an occasional coat of paint, from the day it was opened to the public 60 years ago, is the typical "El" station interior. The turnstile is a fairly recent innovation, having come into use as lately as 1923. Noisy and awkward to handle, it seems as antiquated as the architectural layout and heating apparatus.*

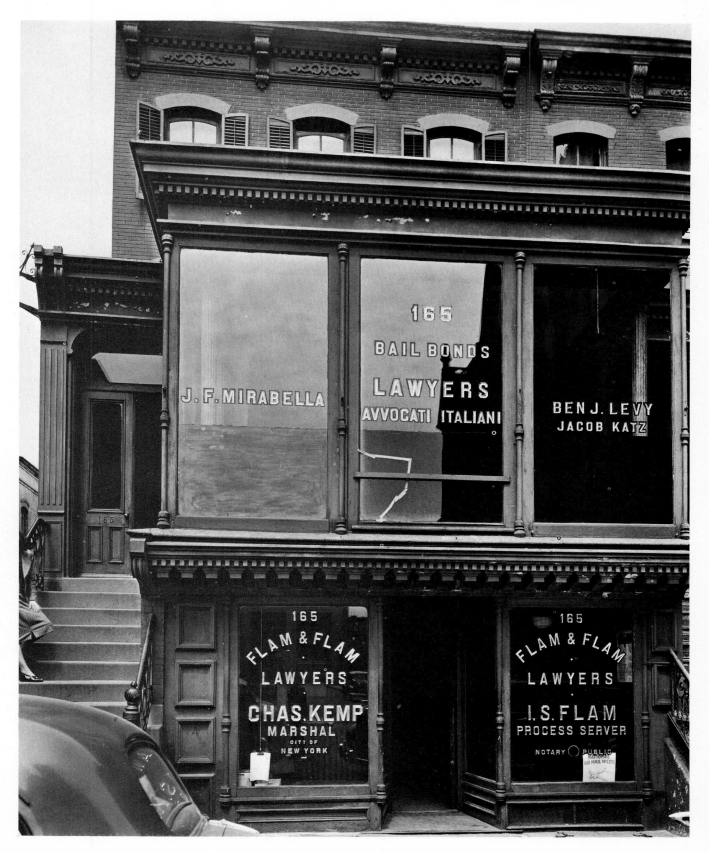

77. FLAM & FLAM, 165 East 121st Street, Manhattan; May 18, 1938.

❧ *Flam & Flam has been located across the street from the Harlem Courthouse for 25 years. Two weeks after the photograph was taken, the firm moved. Originally a church, the building was remodeled into law offices about 1890.*

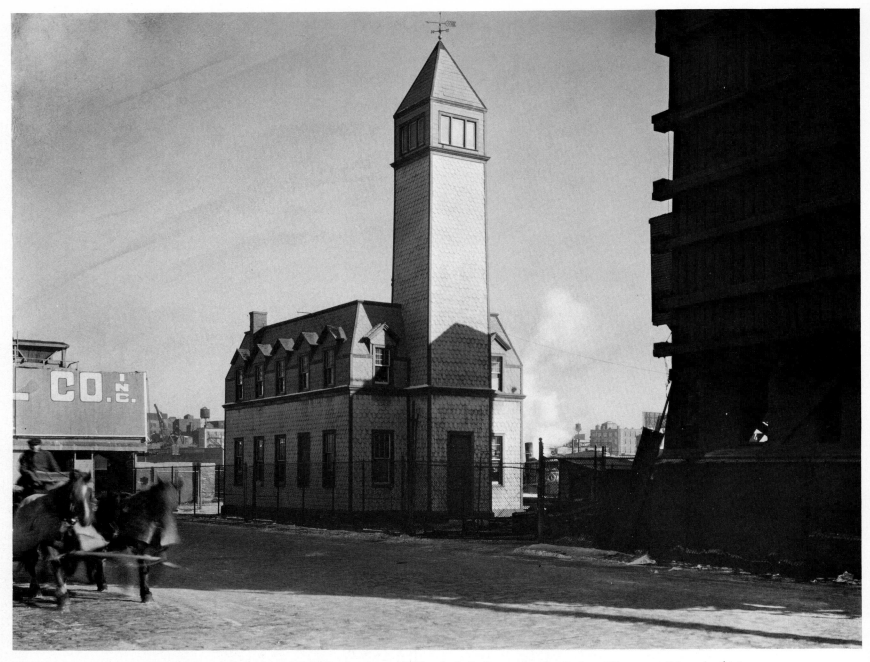

78. FIREHOUSE, PARK AVENUE, East 135th Street, Manhattan, December 19, 1935. Built in 1908. Owned by New York City; under the supervision of the Fire Department.

❧ *The dock firehouse for the fireboat "Lawrence" is only thirty years old; but it resembles an older architecture. Once used for fighting fire on land, it was moved in 1917 from Lexington Avenue and 132nd Street to its present location at the head of Park Avenue, the banks of the Harlem River, and in 1929 subjected to a thoroughgoing alteration.*

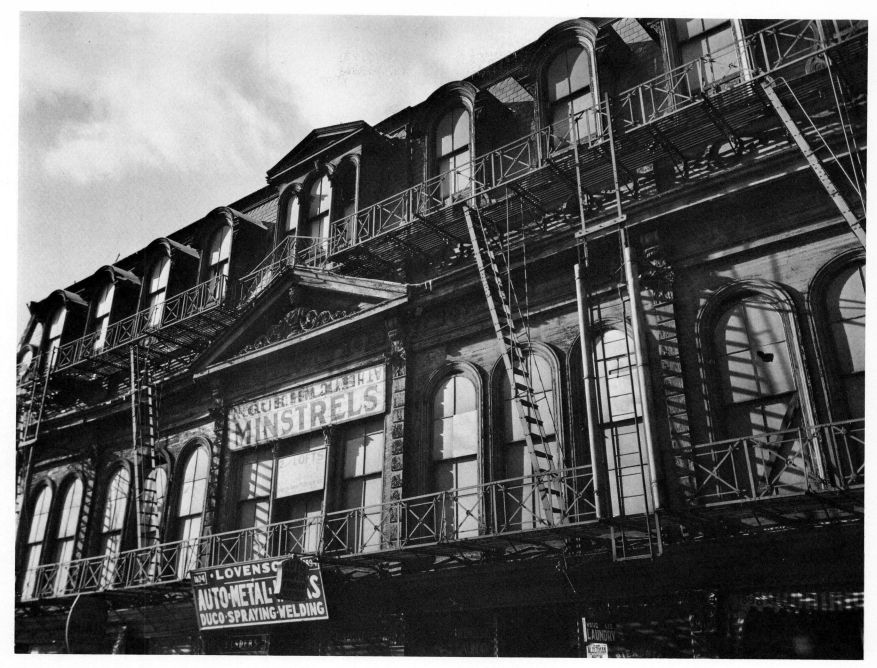

79. GUS HILL'S MINSTRELS, 1890-1898 Park Avenue, Manhattan; December 19, 1935. Built: about 1869.

❧ *Gus Hill's Minstrels has been used as a vaudeville theater, public dance hall, political club gymnasium, fight arena, courthouse and jail. Once owned by "Boss" Tweed, it was deeded to his son in 1872 for $1.00. Twenty years ago it housed Lew Dockstadter's Minstrels, and Gus Hill's Minstrels appeared here. Jack Dempsey, Gene Tunney, Chief Meyers, Bill Brennan and Leo Lomski trained and fought underneath its mansard roof.*

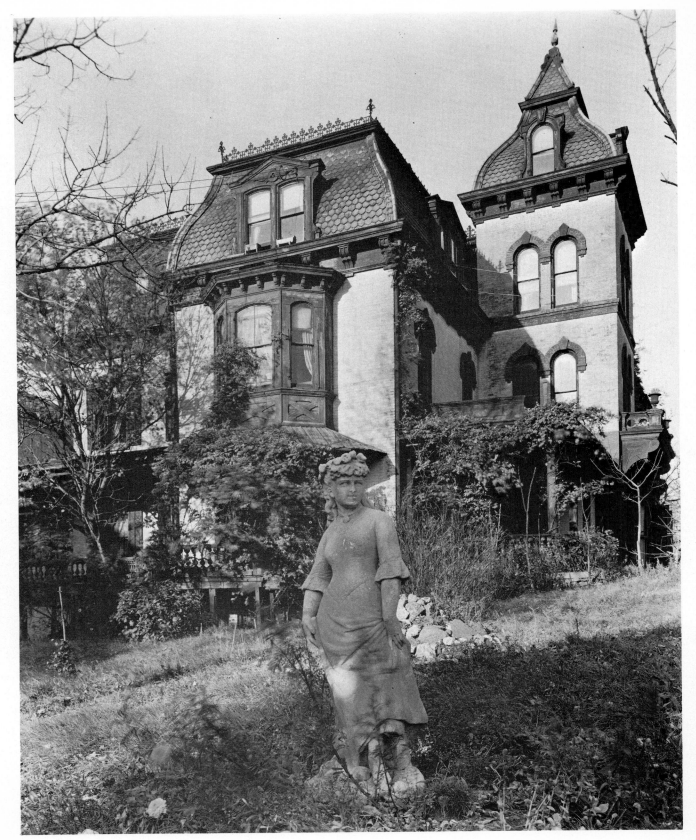

80. WHEELOCK HOUSE, 661 West 158th Street, Manhattan; November 11, 1937.

❧ *Heart-shaped flower-beds of pinks, lilies-of-the-valley, moss roses, peonies and poppies were the fashion of the day when James Gordon Bennett and other men of property built their mansions north of 155th Street. Of this whole neighborhood, but one Victorian house is still in use, the William A. Wheelock house, built about 1860.*

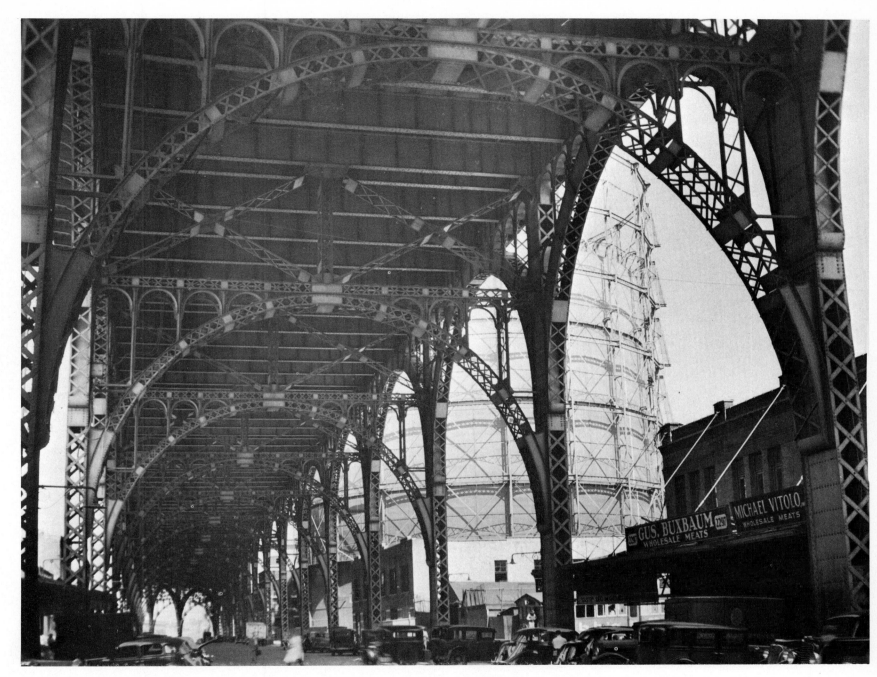

81. UNDER RIVERSIDE DRIVE VIADUCT AT 125th STREET AND TWELFTH AVENUE, Manhattan; November 10, 1937. The viaduct extends from St. Clair Place to 135th Street. Completed 1901. Design and construction supervised by Department of Highways: James P. Keating, commissioner of highways; Andrew Ernest Foxé, chief engineer of highways. Owned by City of New York.

❧ *Forty years old, the Riverside Drive Viaduct represents early highway pioneering. For its steel arches and columns lifted a 60-foot-wide roadway 70 feet high over an intervening valley and made an arterial continuity for traffic in a way which proved increasingly necessary for the growing city.*

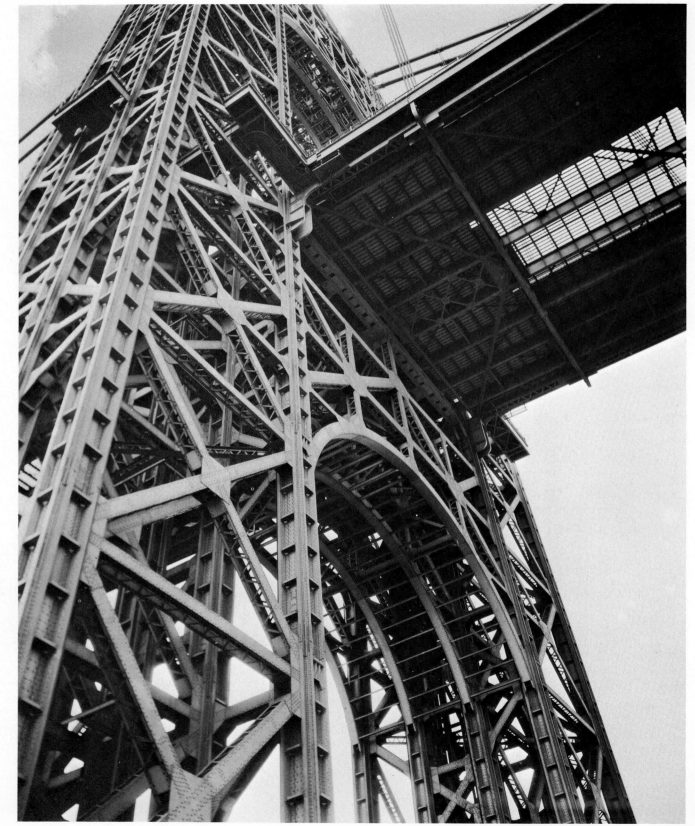

82. GEORGE WASHINGTON BRIDGE, Riverside Drive and 179th Street, Manhattan; January 17, 1936. Completed October 25, 1931. Engineer: O. H. Ammann; chief engineer of design: Allston Dana; architect: Cass Gilbert. Cost $60,-000,000. Owned by Port of New York Authority.

❧ *The great cable towers of the bridge rise 335 feet into the air, two and a third times as high as those of Brooklyn Bridge. Thus in 50 years the physical scale of engineering has more than doubled itself, as may be seen also in the relative length of the main river spans of the two bridges, 3500 and 1600 feet.*

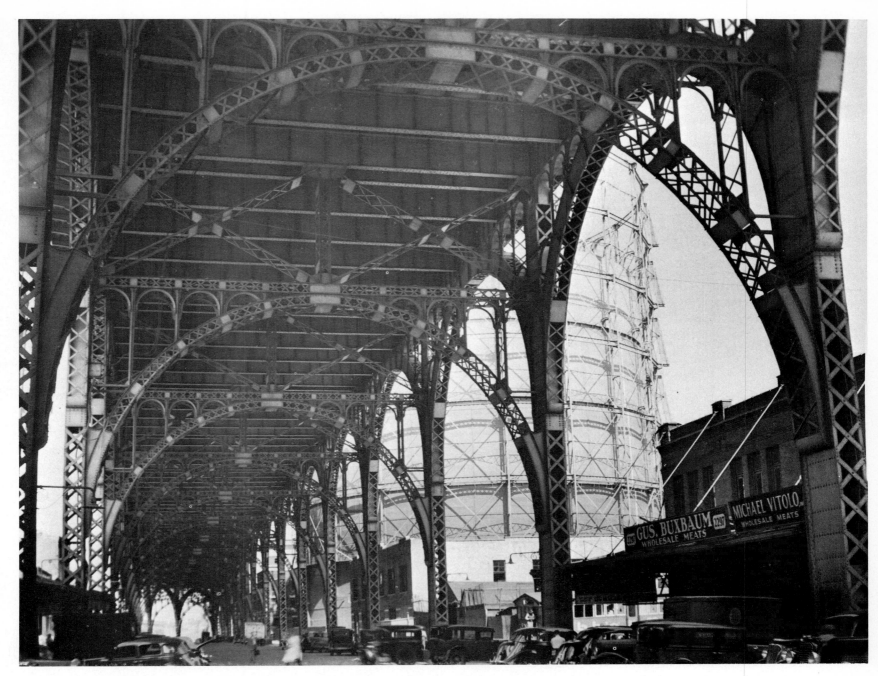

81. UNDER RIVERSIDE DRIVE VIADUCT AT 125th STREET AND TWELFTH AVENUE, Manhattan; November 10, 1937. The viaduct extends from St. Clair Place to 135th Street. Completed 1901. Design and construction supervised by Department of Highways: James P. Keating, commissioner of highways; Andrew Ernest Foxé, chief engineer of highways. Owned by City of New York.

❧ *Forty years old, the Riverside Drive Viaduct represents early highway pioneering. For its steel arches and columns lifted a 60-foot-wide roadway 70 feet high over an intervening valley and made an arterial continuity for traffic in a way which proved increasingly necessary for the growing city.*

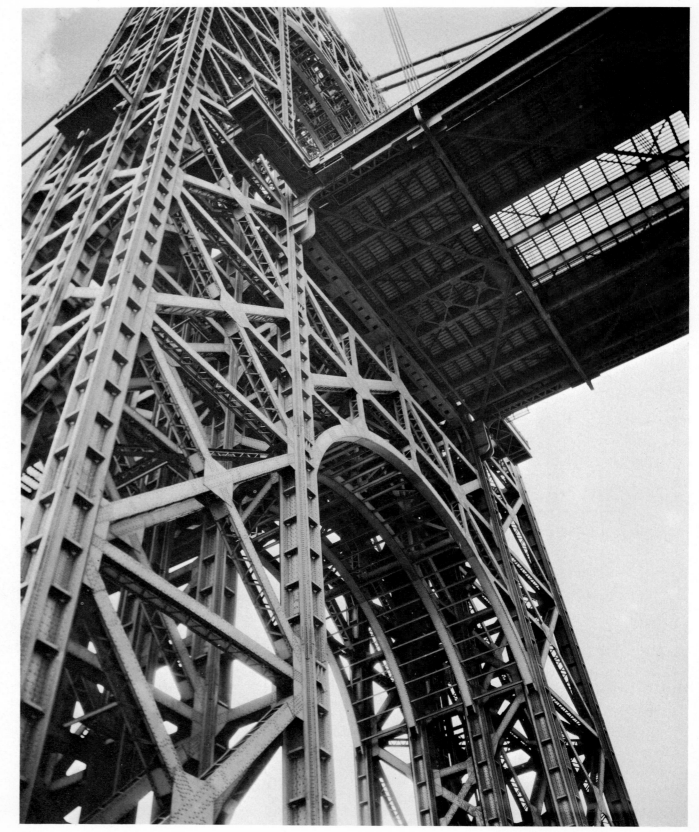

82. GEORGE WASHINGTON BRIDGE, Riverside Drive and 179th Street, Manhattan; January 17, 1936. Completed October 25, 1931. Engineer: O. H. Ammann; chief engineer of design: Allston Dana; architect: Cass Gilbert. Cost $60,-000,000. Owned by Port of New York Authority.

☙ *The great cable towers of the bridge rise 335 feet into the air, two and a third times as high as those of Brooklyn Bridge. Thus in 50 years the physical scale of engineering has more than doubled itself, as may be seen also in the relative length of the main river spans of the two bridges, 3500 and 1600 feet.*

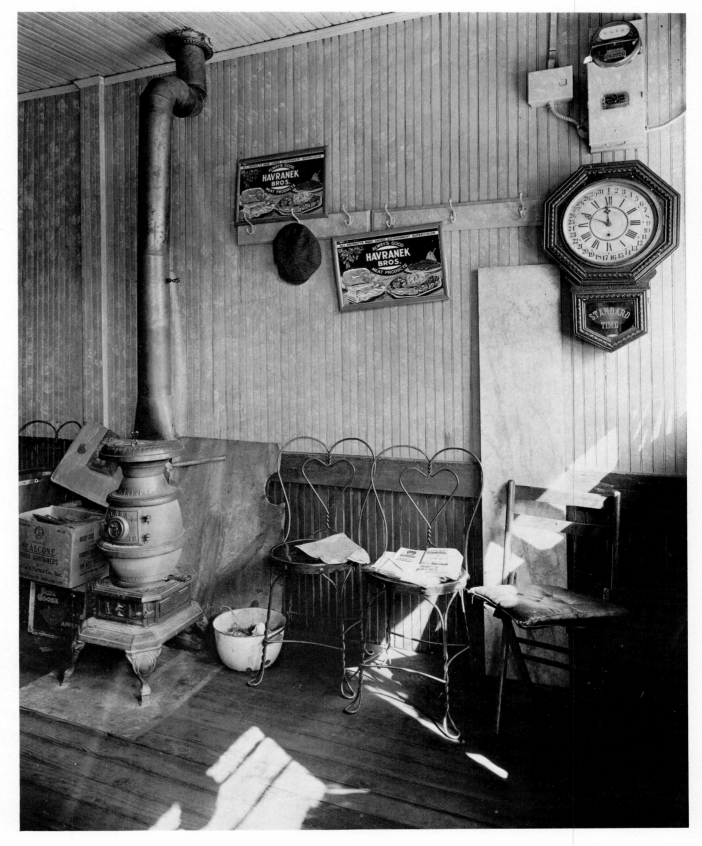

83. COUNTRY STORE INTERIOR, "Ye Olde Country Store," 2553 Sage Place, Spuyten Duyvil, Bronx; October 11, 1935. Built about a century ago by P. Tarantino; now owned by J. Tarantino.

❧ *The Cannon Ball stove and wire chairs were characteristic designs of the turn of the century. Distributed throughout the United States, the stove was manufactured from 1904 to 1914 and sold for about $20. Repair parts are still available. Chairs of this type had their heyday before the war. They sold retail for $2.50.*

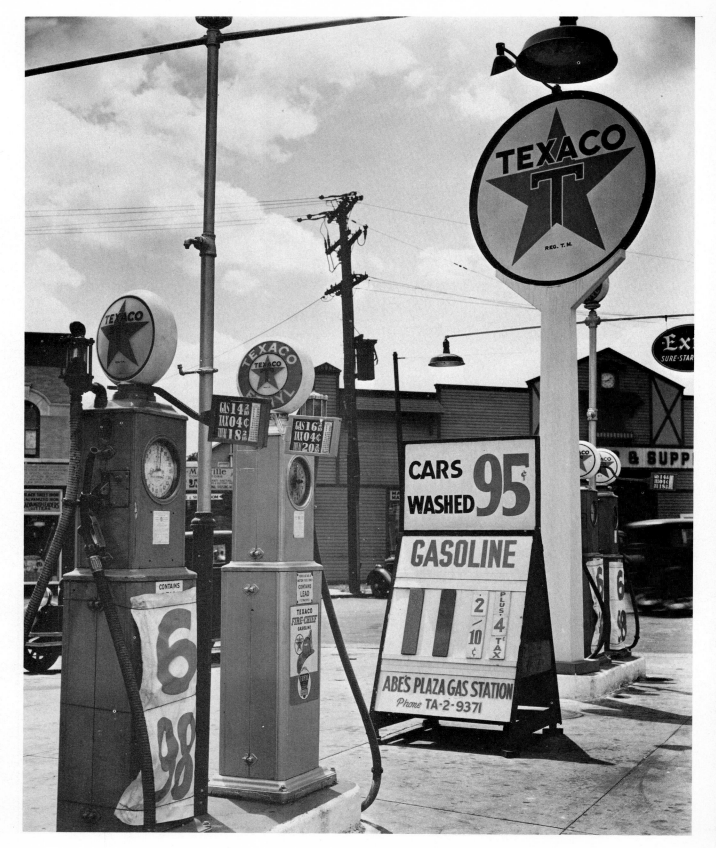

84. GASOLINE STATION, Tremont Avenue and Dock Street, Bronx; July 2, 1936.

❧ *"Abe's Plaza gas station" is one of the many which sell an aggregate of 20,000,-000,000 gallons of gas yearly to the American public at a cost of $3,000,000,-000, supporting a petroleum industry with a total capital investment of $13,-276,000,000.*

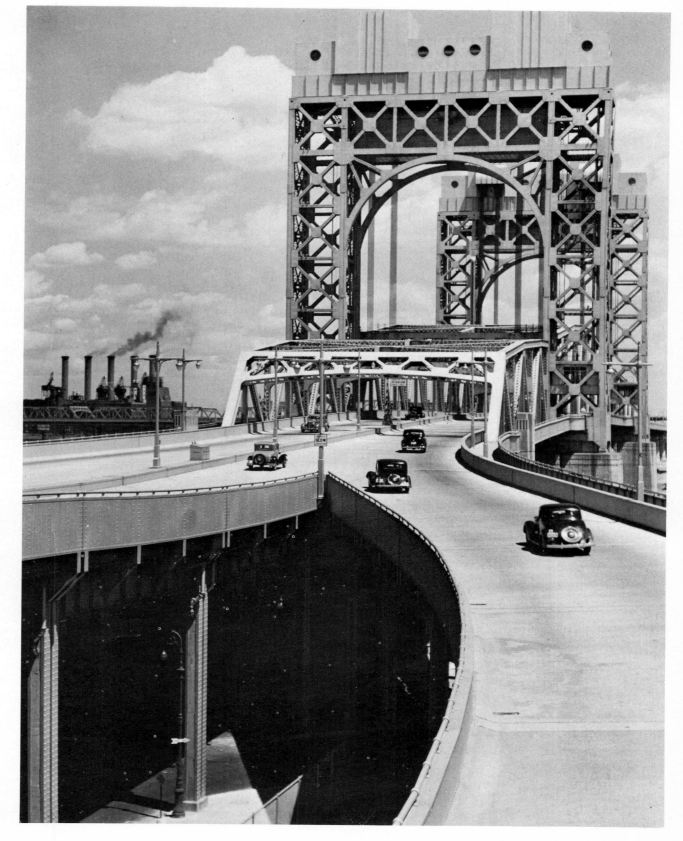

85. TRI-BOROUGH BRIDGE: EAST 125th STREET APPROACH, Manhattan; June 29, 1937. Built: 1929-1936. Chief engineer: O. H. Ammann. Cost: $60,000,000. of which two-thirds was made up of PWA loans and direct government grants. Opened by President Roosevelt July 11, 1936.

❧ *The viaducts, ramps, depressed roadways and clover-leaf junction of the Tri-Borough Bridge's 19-mile express highway system link the borough of Manhattan, Queens and the Bronx. Long viaducts and four bridge spans, measuring 17,710 feet, comprise the elevated part of the bridge. The bridge proper consists of the Harlem span; the Bronx Kills span, connecting the Bronx with Randall's Island; the concrete arches across Little Hell Gate to Ward's Island; and the span from Ward's Island across the East River to Queens.*

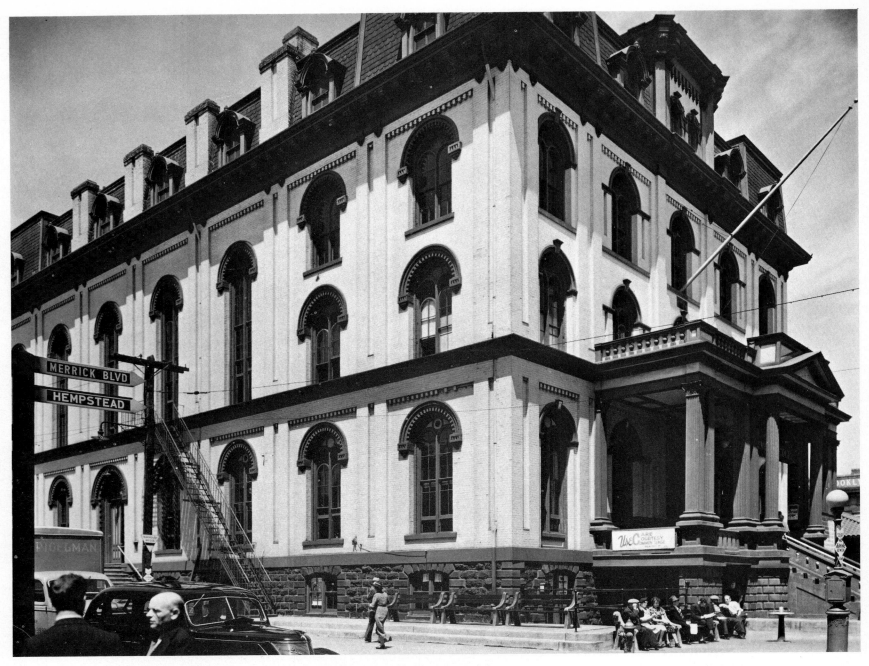

86. JAMAICA TOWN HALL, 159-01 Jamaica Avenue, Jamaica, Queens; June 1, 1937. Occupies 141 feet on Jamaica Avenue, 250 feet on Flushing. Built: 1870.

❧ *The Jamaica Town Hall of "Boss" Tweed's day now shelters the Traffic Court, the Small Claims Court, and the Fourth District Municipal Court.*

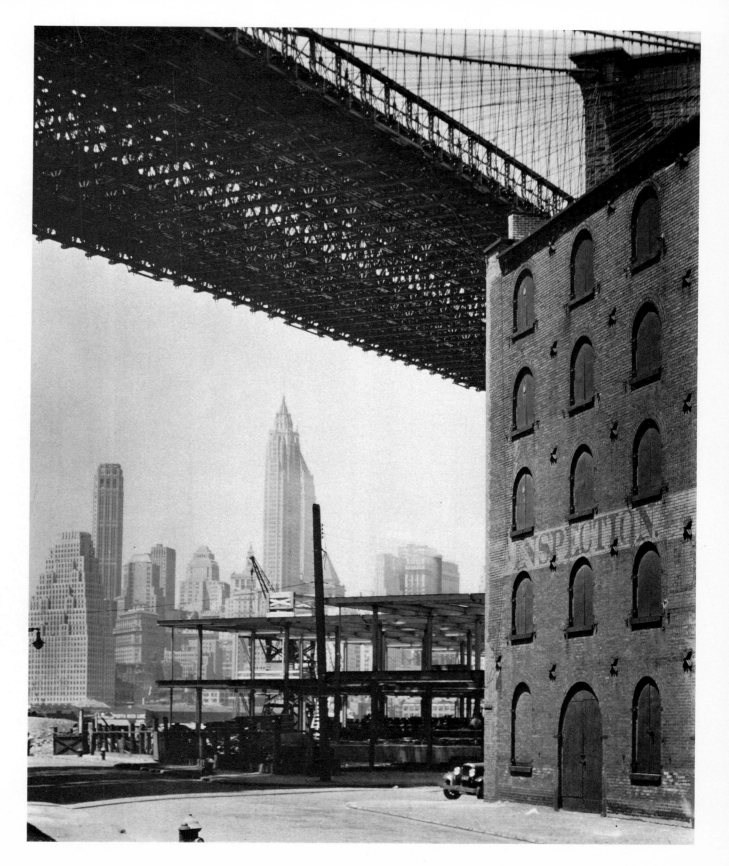

87. BROOKLYN BRIDGE, Water and Dock Streets, Brooklyn; May 22, 1936. Designed and built by engineers John A. Roebling and Col. Washington A. Roebling; opened to public May 24, 1883; construction cost, $15,211,982.92 and land cost, $10,000,000; originally owned by private company, now by New York City under the supervision of the Public Works Department.

❧ *Brooklyn Bridge is the technological ancestor of all the great steel cable suspension bridges which connect Manhattan Island with the world. The Roeblings' success in devising a steel cable strong enough to support the strain of its mighty spans opened the way for the Williamsburg, Manhattan and George Washington Bridges.*

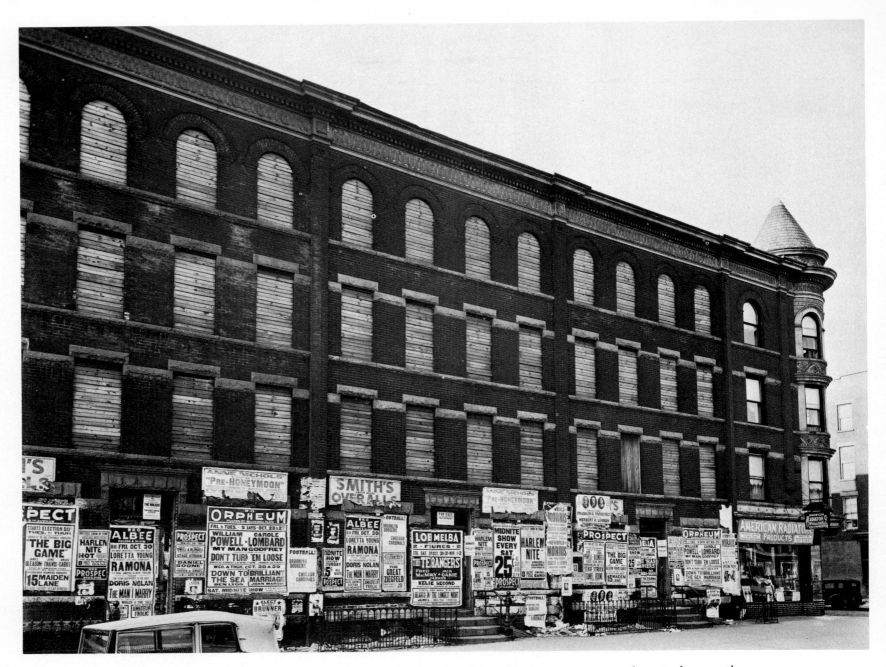

88. FOURTH AVENUE, NO. 154, Brooklyn; October 29, 1936.

❧ *These Brooklyn old-law tenements stand empty because the present owner prefers to take a loss on taxes and insurance rather than meet the cost of removing violations. Fire escapes and fire retarding of stair wells are the principal requirements.*

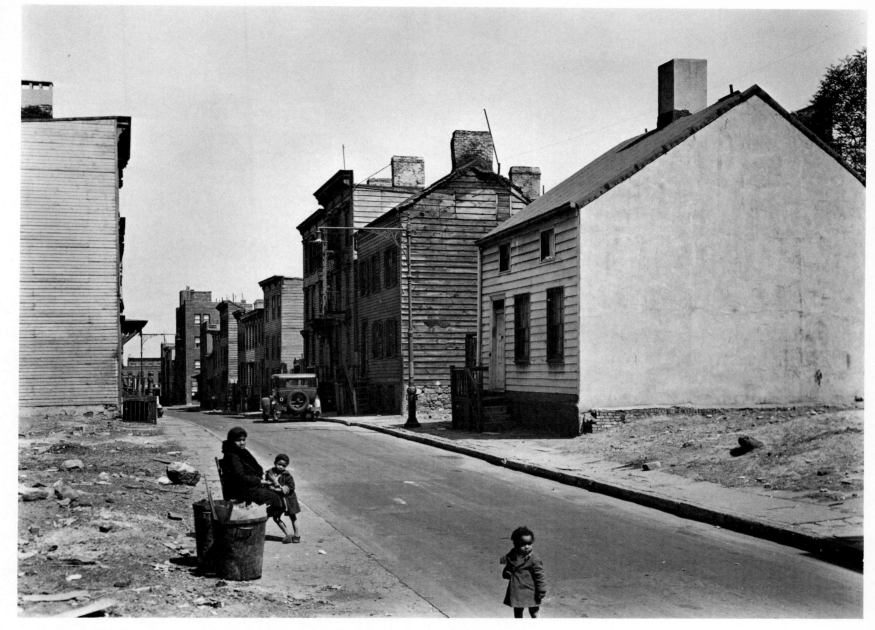

89. TALMAN STREET, BETWEEN JAY AND BRIDGE STREETS, Brooklyn; May 22, 1936.

☘ *The condemned old-law tenements of "Irishtown," Brooklyn, have no hot water, no central heating, no bathtubs. Negro families now share the neighborhood with the earlier Irish settlers.*

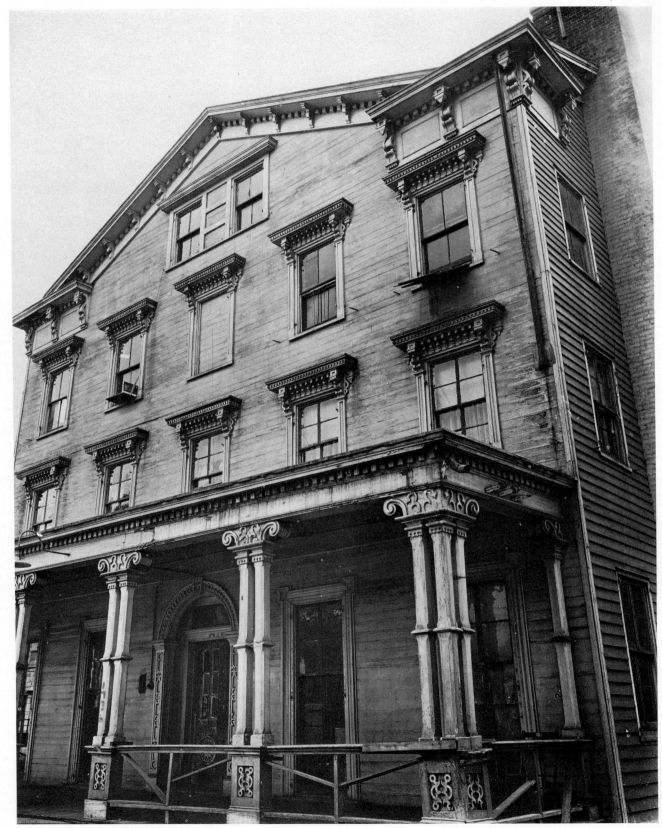

90. CROPSEY AVENUE, No. 1736, Brooklyn; October 29, 1936.

❧ *Fashionable resort of the eighties, Bath Beach experienced a decline in recent years till this handsome survivor of the General Grant era became a restaurant and cabaret. Progress of the metropolitan highway system overtook it in 1937, and it had to make way for the Shore Road Extension from Dyker Beach Park to Bensonhurst.*

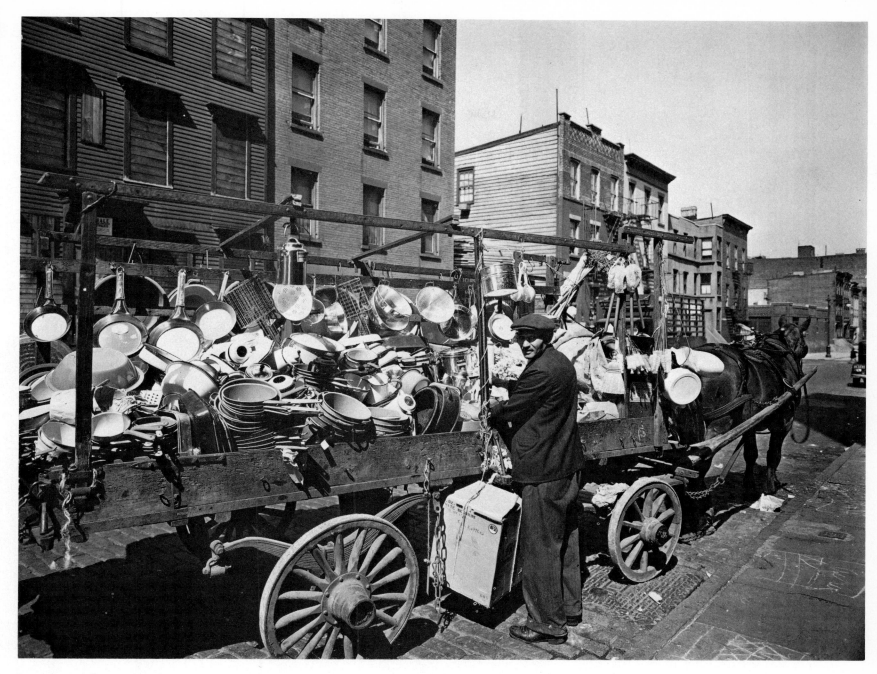

91. TRAVELING TIN SHOP, Brooklyn; May 22, 1936.

❧ *Wagon peddlers pay a $10 license, pushcart peddlers only $4. Both are being legislated off the streets of New York, as more modern and rigid market ordinances are passed and enforced.*

92. WILLIAMSBURG BRIDGE, from South 8th and Berry Streets, Brooklyn; April 28, 1937. Extends from Clinton and Delancey Streets, Manhattan, to New Street, Brooklyn. Built by Cities of Brooklyn and New York; now owned by New York City. Engineer: Leffert L. Buck. Cost originally estimated at $7,000,000. Actual expenditures were: for construction, $15,175,389.79; for land $9,096,593.67.

❧ *Agitation for the construction of a bridge or tunnel at approximately the present site of the Williamsburg Bridge began 20 years before this bridge was actually completed. Work got under way in 1896, and the bridge was opened to traffic December 19, 1903. An important engineering feature of the construction was the depth to which the caissons were sunk, 110 feet.*

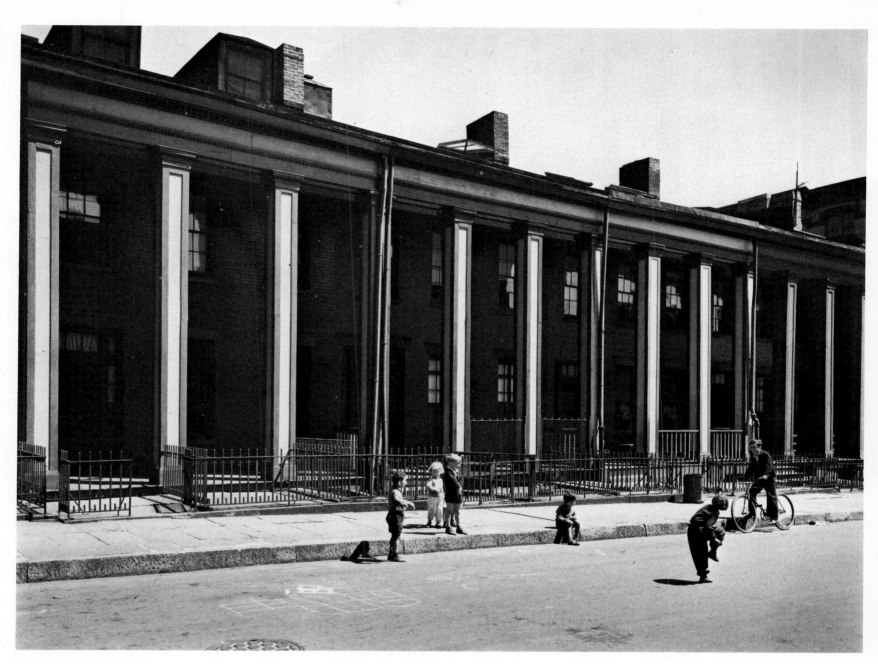

93. WILLOW PLACE, NOS. 43-49, Brooklyn; May 14, 1936. Owned by: Meehan, Sullivan, McKenna and Dowling families.

❧ *Among the present residents of these Greek Revival mansions in Brooklyn is a woman, three generations of whose family have lived in this row and owned their own home. But the houses no longer maintain the earlier glory implied in the dignity of the facade. They are almost unimproved and portable kerosene stoves supply heat.*

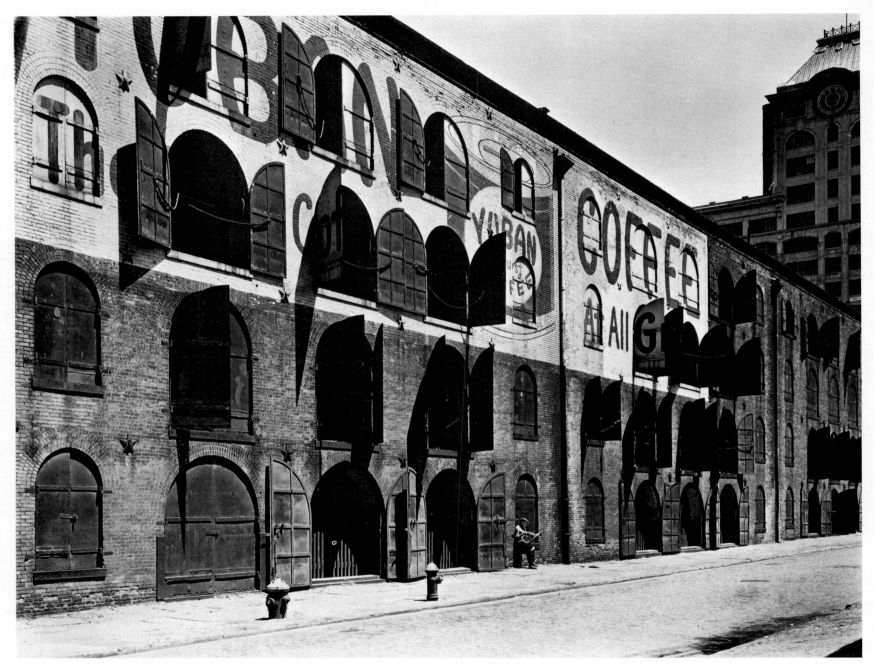

94. WAREHOUSE, Water and Dock Streets, Brooklyn; May 22, 1936.

❧ *Built about 1884 by Arbuckle Bros. for the storage of green coffee, the warehouse nestling under Brooklyn Bridge was sold with the trade name "Yuban" and their entire coffee business, to General Foods, one of the vast cartels of the food industry. It is still used to store green coffee. The roasting is done across the river in Manhattan, for the most part.*

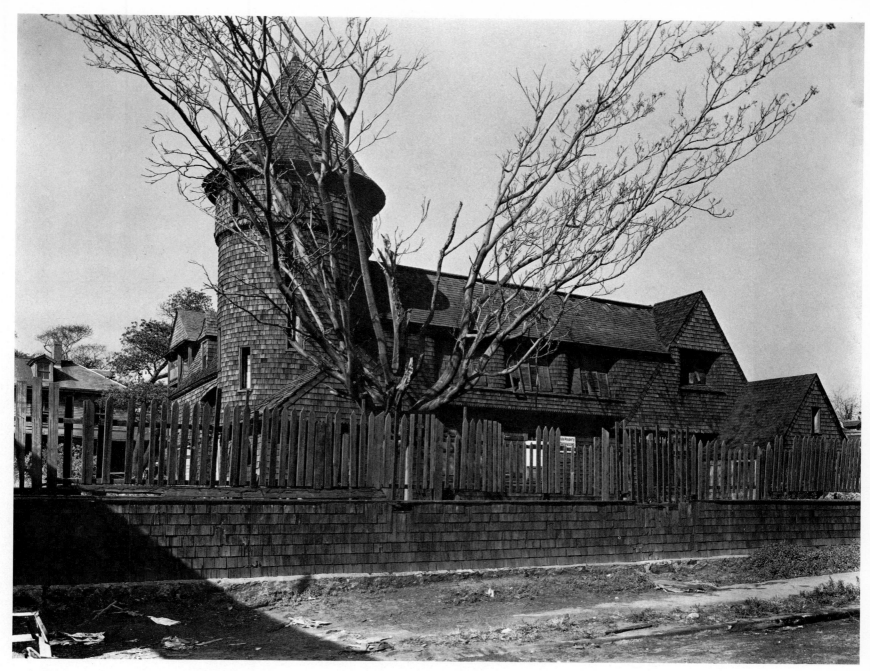

95. CHILDREN'S AID SOCIETY SUMMER HOME, 1750-1818
Cropsey Avenue, Brooklyn; October 27, 1936. Summer home
founded in 1881; its numerous buildings added for over 20 years.

❧ *From 1881 to 1929, the Children's Aid Society's Summer
Home flourished at Bath Beach, once a resort frequented by
Astors and Vanderbilts. In 1938 demolition of the buildings be-
gan, to make way for the Shore Road Extension from Dyker
Beach Park to Bensonhurst Park. The cottage shown, "Green
Corridor," typifies the simple domestic architecture which char-
acterized the society's eleven buildings.*

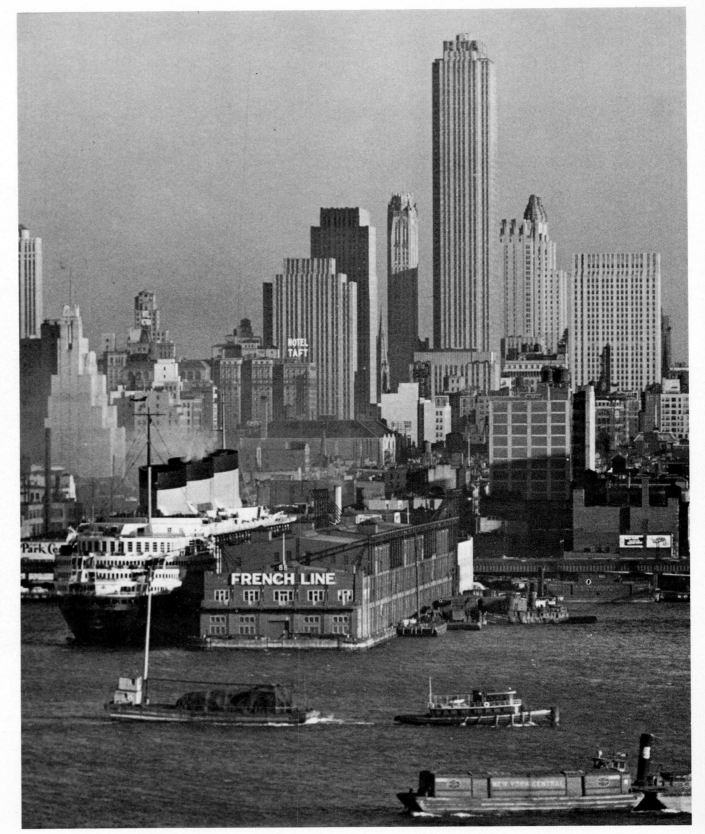

96. MANHATTAN SKYLINE, from Boulevard East and Hudson Place, Weehawken, New Jersey; November 9, 1937. Left to right (starting with the building behind the "Hotel Taft" sign) are: RKO Building, International Building, General Electric Building, R. C. A. Building, Waldorf-Astoria, and Time & Life Building.

Flanking the central tower of Rockefeller Center, the 1000-foot-high R. C. A. Building, are to the left the General Electric Building on Lexington Avenue and to the right the Waldorf-Astoria on Park Avenue. The optical phenomenon which brings these buildings into one plane has foreshortened the 1000-foot-long "Normandie" till it looks scarcely longer than a tug.

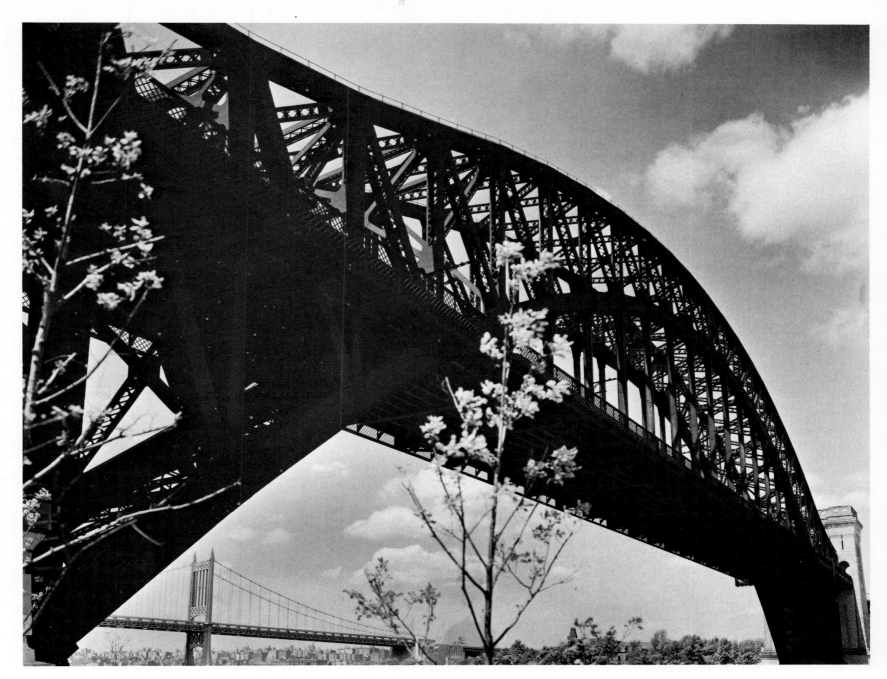

97. HELL GATE BRIDGE, central steel arch over East River, from Astoria Park, Astoria, Queens; May 25, 1937. Built: 1917. Engineer: Gustav Lindenthal. Cost, $5,000,000.

❧ *Connecting link for rail travel between Canada, New England and the Southwest, the Hell Gate Bridge differs radically in design from New York's other bridges. Its steel arch, spanning 1017 feet, and concrete viaducts three miles long make an admirable by-pass from the New York, New Haven and Hartford system to the Pennsylvania. The long, sinuous form is a monument to Lindenthal's audacity in designing this great parabolic span in steel after engineers had believed the era of the arch ended by the girder and beam.*